WHO
RESCUED
WHOM?

dog portraits
& rescue stories

MARGARET BRYANT

AMHERST MEDIA, INC. ■ BUFFALO, NY

Published by:
Amherst Media, Inc.
PO BOX 538
Buffalo, NY 14213
www.AmherstMedia.com

Publisher: Craig Alesse
Associate Publisher: Katie Kiss
Senior Editor/Production Manager: Michelle Perkins
Editors: Barbara A. Lynch-Johnt, Beth Alesse
Acquisitions Editor: Harvey Goldstein
Editorial Assistance from: Carey A. Miller, Roy Bakos, Jen Sexton-Riley, Rebecca Rudell
Business Manager: Sarah Loder
Marketing Associate: Tonya Flickinger

ISBN-13: 978-1-68203-384-5
Library of Congress Control Number: 2018960368
Printed in the United States of America
10 9 8 7 6 5 4 3 2 1

AUTHOR A BOOK WITH AMHERST MEDIA

Are you an accomplished photographer with devoted fans? Consider authoring a book with us and share your quality images and wisdom with your fans. It's a great way to build your business and brand through a high-quality, full-color printed book sold worldwide. Our experienced team makes it easy and rewarding for each book sold—no cost to you. E-mail submissions@amherstmedia.com today.

www.facebook.com/AmherstMediaInc
www.youtube.com/AmherstMedia
www.twitter.com/AmherstMedia
www.instagram.com/amherstmediaphotobooks

CONTENTS

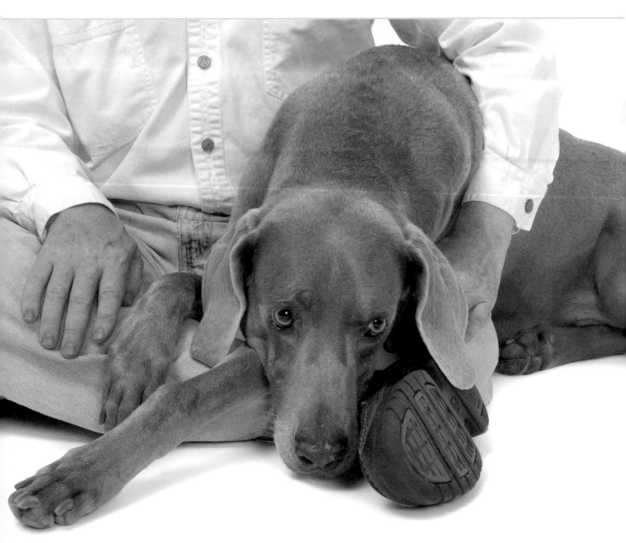

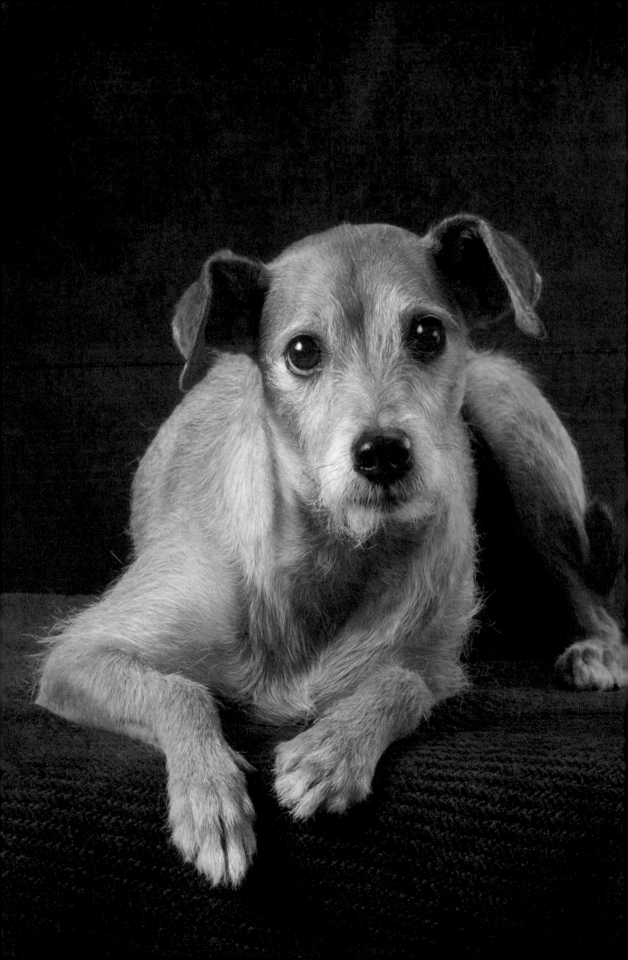

ABOUT THE AUTHOR

Margaret Bryant is an award-winning photographer who specializes in photographing dogs and their people. Her style is simple, original, and authentic, and often shows the humor and whimsy of dogs.

Starting her business in 1998, Margaret has specialized in dogs and their humans from the very start. She is knowledgeable about dog breeds, dog behavior, dog training, and dog sports.

Professional development is important to Margaret, and she has earned her Master of Photography and Photographic Craftsman degrees from the Professional Photographers of America (PPA). She is also a Certified Professional Photographer with PPA. Margaret is a multiple PPA Photographer of the Year medalist, a multiple Grand Imaging Award finalist, and has numerous images in the PPA Loan and Showcase Collections.

Margaret shares her knowledge with other photographers with speaking, teaching, private coaching, and writing. She frequently speaks about pet photography and copyright to various photographic groups, and can make a potentially boring subject animated and interesting.

In March 2017, Margaret's first book was published. Titled *Dog Photography: How to Capture the Love, Fun, and Whimsy of Man's Best Friend,* the book is about understanding dog behavior, and making a dog comfortable in order to create some great images. It addresses handling, props, and posing dogs alone and with their people.

Margaret gives back to the animal community by raising cash for local spay/neuter clinics with her Bow WOW Sessions.

Acknowledgments. The people who told the stories in this book were from a variety of sources, some were word of mouth, and some people Margaret already knew.

However, this book would not have been possible without the help of a few rescue groups who told Margaret stories of rescued animals and provided her with the contact information for possible participants. These are rescue people who have put their heart and soul into bettering the lives of dogs. They work tirelessly, and sometimes at great expense, to make a difference in the lives of animals. Margaret thanks them for all of their help with this book and all that they do for rescue every day. They are:

- Angie's Friends
 http://angiesfriends.org
- Oak Hill Animal Rescue
 http://www.ohar.org
- Weimaraner Rescue of Texas
 http://www.weimrescuetexas.org

INTRODUCTION

I heard some wonderful stories of rescued dogs while preparing this book. I was able to photograph many of the dogs whose tales I heard. Though I didn't have the opportunity to photograph one dog whose story I heard, it's worth mentioning here that it was about a family who adopted a dog, and later found out that dogs were not allowed in their apartment building—so they moved!

I love that story, since usually, when an owner cannot keep a dog, the pet winds up being dumped somewhere. There are good people out there who have the dog's best interest at heart.

Some of the stories in this book are about individual people rescuing individual dogs, and others are about some of the wonderful rescue groups that are doing the sometimes expensive, sometimes thankless job of dog rescue.

I got to meet some wonderful dogs and some incredibly giving people. Here are their stories; some told by the people, and some "told" by the dogs themselves.

About This Book. Every year, millions of unwanted dogs are surrendered at animal shelters, abandoned on country roads, or kicked to the street. Dogs are not hunters. They are opportunists and scavengers. Over thousands of years, we have created an animal to be dependent on us, to work for us, and to do our bidding. They have a difficult time surviving without people to help them.

Municipal shelters, community no-kill shelters, and rescue groups can provide the safety net that lost or abandoned dogs need to survive. To be sure, not all will survive, and these remedies are far from perfect, but for now, it is the best chance these animals have.

This book is the story of dogs who were rescued from a life of uncertainty. They may have been found at an animal shelter or rescue group, seen lost on a lonely country road, or found wandering aimlessly on a city street. They were taken in by people who wanted to make them part of their family. They were given a chance at a better life, and that has made all of the difference.

"This book is the story of dogs who were rescued from a life of uncertainty."

"Every year, millions of unwanted dogs are surrendered at animal shelters, abandoned on country roads, or kicked to the street."

ENRICHING OUR LIVES

● Harper Lee

"My dad's hands are magical. Thirty-five years as a high school agriculture and wood shop teacher have etched a lifetime of experience into them. His calloused and weathered fingers have instructed thousands of students, created countless works of art, and soothed an infinite number of livestock and household pets. Due to Alzheimer's disease and a hearing impairment, Dad's activities are now limited, but his gentle strength and love for animals are still evident as he lovingly caresses Harper Lee, our beloved Weimaraner.

An unspoken bond exists between dog and man. A simple touch by a seasoned hand, and no words are necessary. A few years ago, a dog in need of understanding, support, and unconditional love was rescued by a family. In reality, my dog and my family continue to rescue each other."

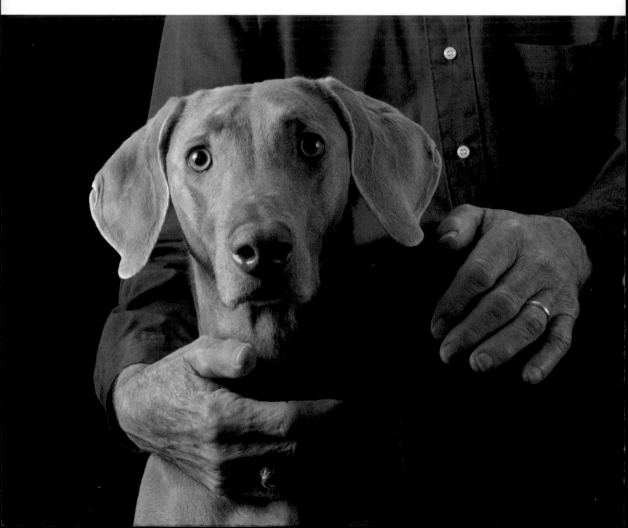

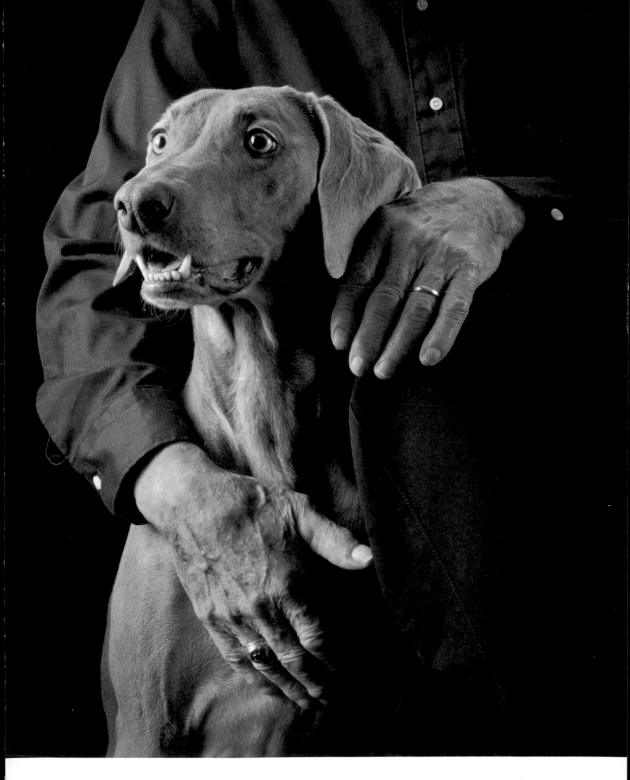

● Gracie

"Gracie was rescued as a blind and emaciated Weimaraner puppy. As it was only by the grace of God that she was still alive, we named her Gracie. We would not have chosen a blind puppy to bring into our home, but then, we often don't get to choose what happens to us. We agreed to foster her. We would nurse her back to health and find the perfect home for her.

We almost lost her the first weekend, but her spirit was strong, and she fought her way back. Soon, we knew that Gracie was special. After a while, we knew we couldn't trust her care to anyone else, so she became part of our family.

As for 'saving,' Gracie—sure, we nursed her physical body back to health, but she has given us far more. She has taught us more about unconditional love than we ever thought possible, and has filled our hearts and home with her gentle spirit."

"She has taught us more about unconditional love than we ever thought possible, and has filled our hearts and home with her gentle spirit."

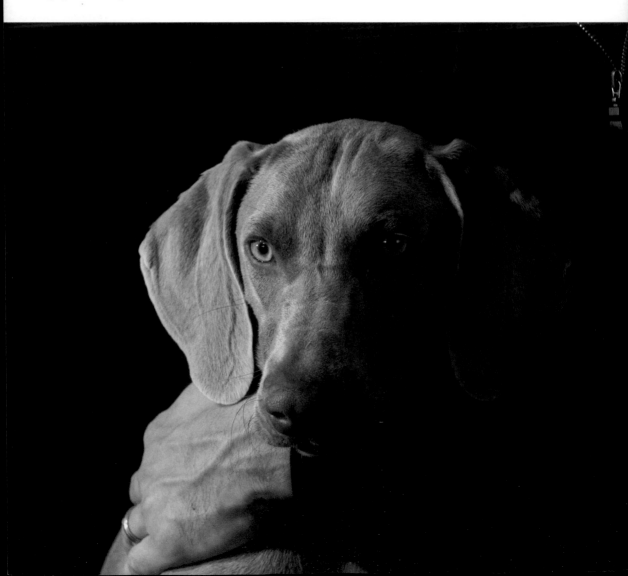

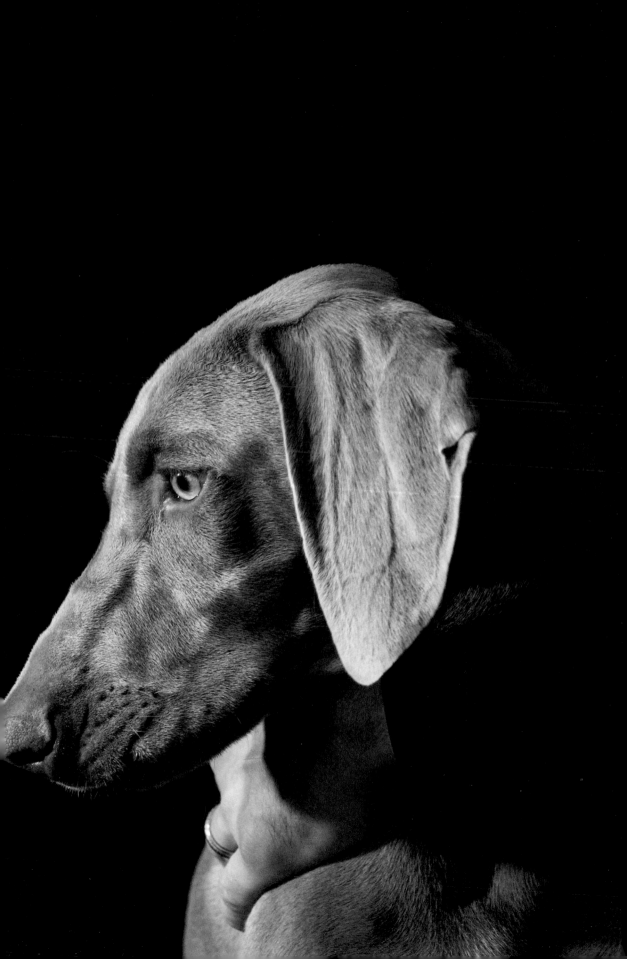

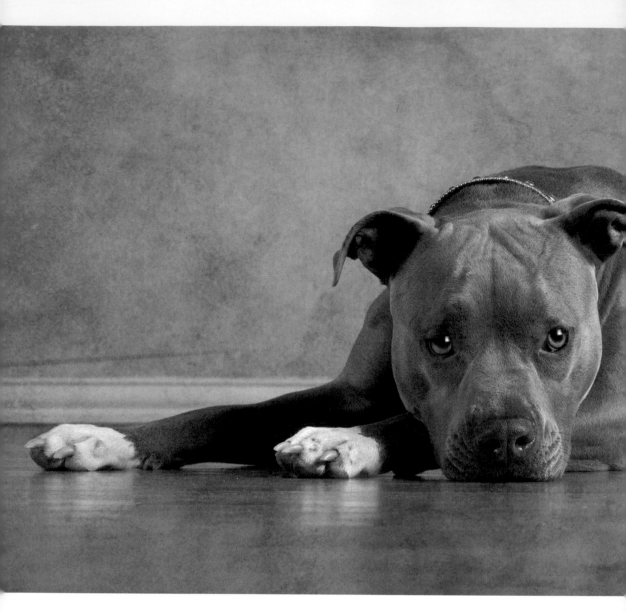

● Sasha

"I first saw Sasha outside a local pet store when she was a puppy. I feared since she was a Pit Bull, she was going to be used as a bait dog for dog fighting. I offered to foster her until a home could be found for her.

She wrapped me around her little paw. I was ready to find her a new home, when I realized I was in love. It wasn't long before it became clear that my home would be Sasha's forever home. We started puppy training, and she graduated at the top of her class. We progressed to intermediate training, then moved on to advanced training, agility training, Canine Good Citizen classes, and more.

Sasha is my companion at baseball games, on vacations, and our 'date' nights at the local dog cafe. Her favorite activity is to get a free 'puppuchino' from the local coffee shop.

Sasha could have ended up in a dog fighting ring. I rescued her. But she rescued me, too. I have been transformed from someone who kept to herself, to a happy, outgoing person who enjoys getting out, socializing, and having fun with my dog and other people. Sasha has opened up a whole new chapter in my life."

"She wrapped me around her little paw. I was ready to find her a new home, when I realized I was in love."

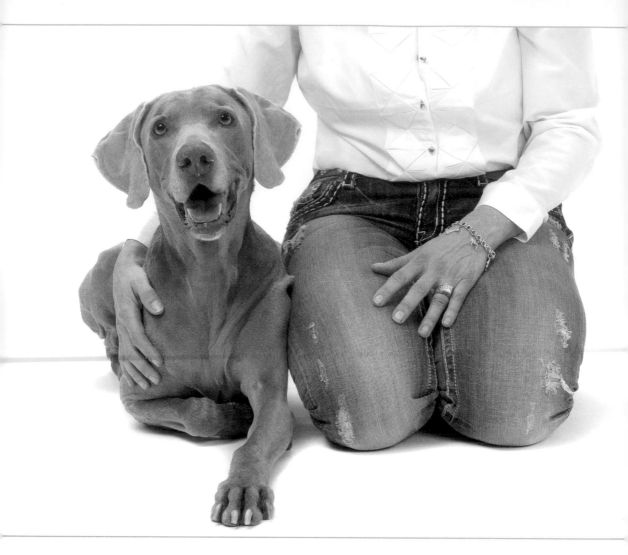

● Bubba

"Bubba was a foster failure from Weimaraner Rescue. Forty-eight hours after we started to foster him, we knew he had to be ours.

I love his big head on my legs, or his front paws on my chest and shoulders when we lie together on the sofa. As close as he wants to be with me, it pales in comarison to the closeness I long to have with him. He is my little shadow, and I can't imagine my life without him.

I truly believe that all dogs that are adopted know they are saved, but I think they save *us*

in the process. We didn't really choose Bubba. Bubba chose us from the minute he walked into our home and stole our hearts."

"I truly believe that all dogs that are adopted know they are saved, but I think they save us in the process."

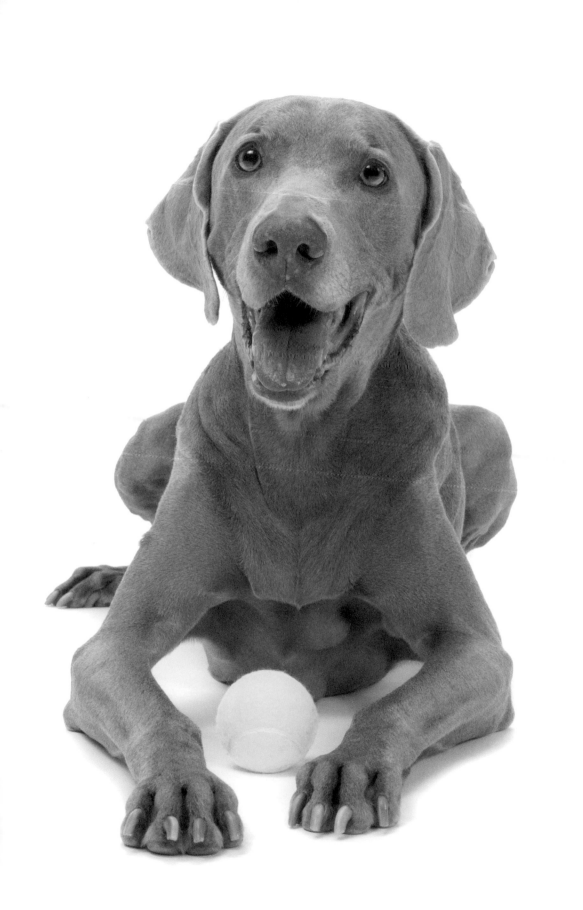

● Scotty

"Scotty was with a rescue group for over two years. He was adopted once, but was returned four months later. We found out the reason after Scotty had stayed with us for a month: Scotty has an extreme anxiety issue. He would whine, shiver, and pace nonstop for no obvious reason, but for the insecurity and demons inside his handsome head.

Scotty has been on Prozac for over a year. He's calmer and more comfortable now. What Scotty does the most is give kisses. I assume that kissing is his way of building relationships.

Ever since Scotty became a member of our family, I come home every day during my lunch break so he won't feel so insecure. I look forward to spending every lunch time with my dear Scotty, snuggling with him, and letting him give me his sweet kisses."

"I look forward to spending every lunch time with my dear Scotty, snuggling with him and letting him give me his sweet kisses."

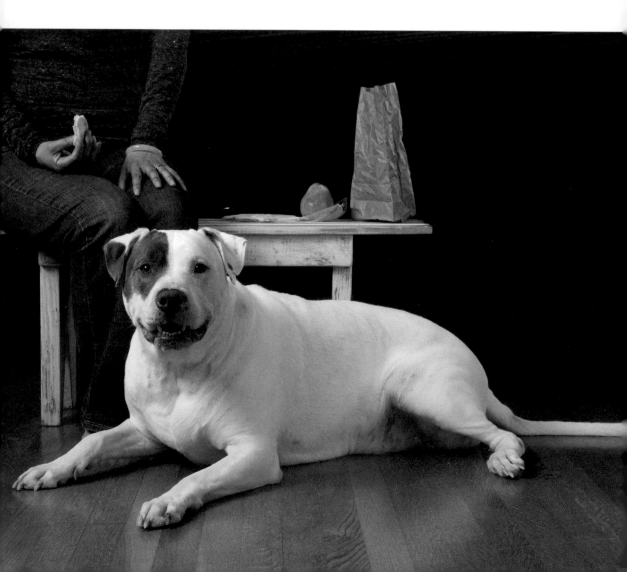

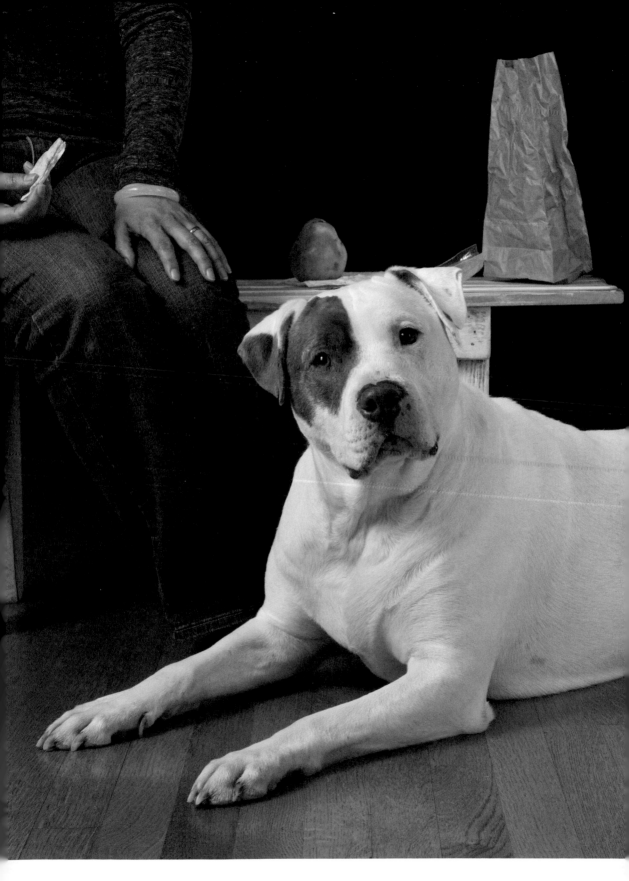

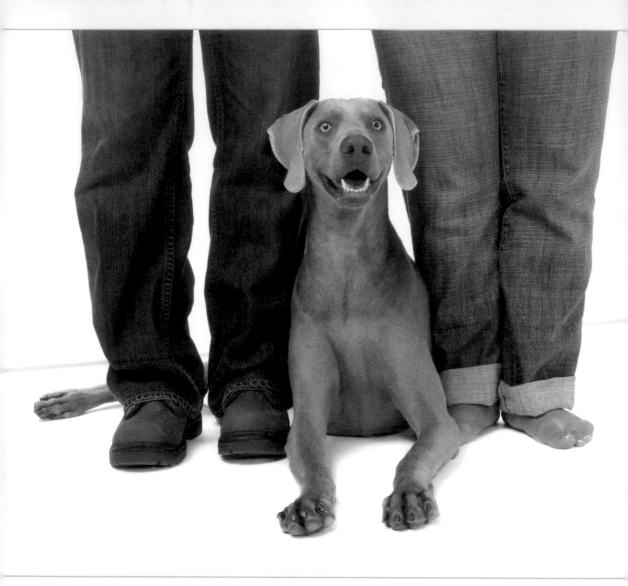

● Billy

"We cannot remember a life without Billy. He has enriched our lives beyond what words can describe. From the moment he entered our house, we fell in love with him. He has done nothing but love us unconditionally in return.

We truly believe Billy knows he has been permanently rescued. We have watched him transform from a timid, anxious dog, to a loving, confident one. He knows we are family and belong together. Billy is as much our best friend as he is our son, and we cannot imagine our lives without him."

"We truly believe Billy knows he has been permanently rescued. We have watched him transform from a timid, anxious dog, to a loving, confident one."

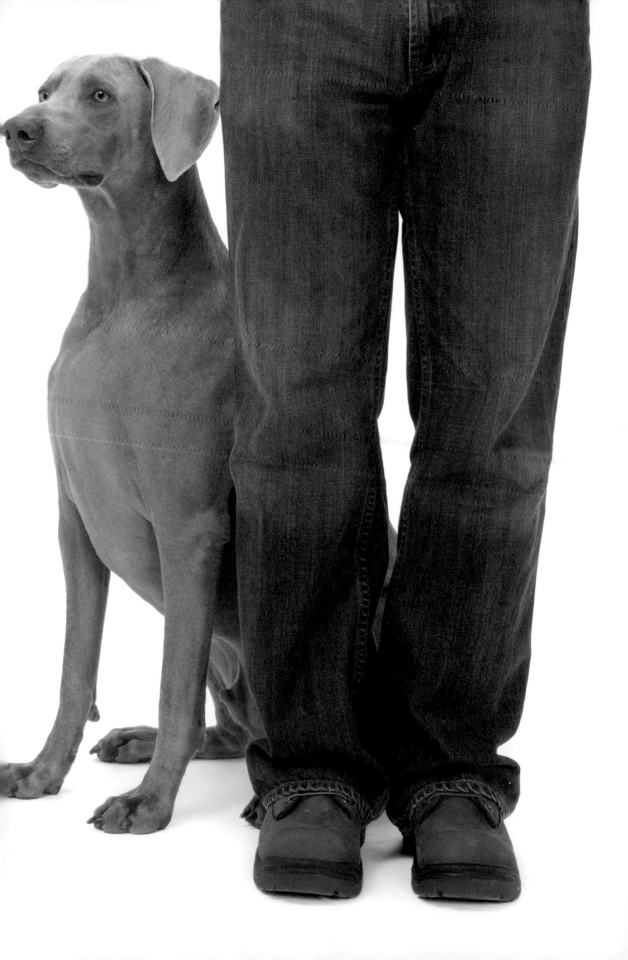

MEANT TO BE

● Udo

"Udo came from a listing on Petfinder. The owner's daughter had gotten him from the shelter a couple of years before. The mom had taken a job as a flight attendant and sometimes was gone for weeks at a time. The daughter convinced her mom that the dog needed a better home.

The dog was a mess. He had no manners. He jumped on everyone. He was the worst dog ever. I agreed to take him, because it was what my now ex-husband wanted.

Fast forward all these years, and the dog I didn't want is now the greatest dog ever, and truly everyone's best friend. He loves to play ball (which he is very bad at) and point at rabbits in the backyard. He loves to go places, and any place is fine with him. He mostly loves to hang

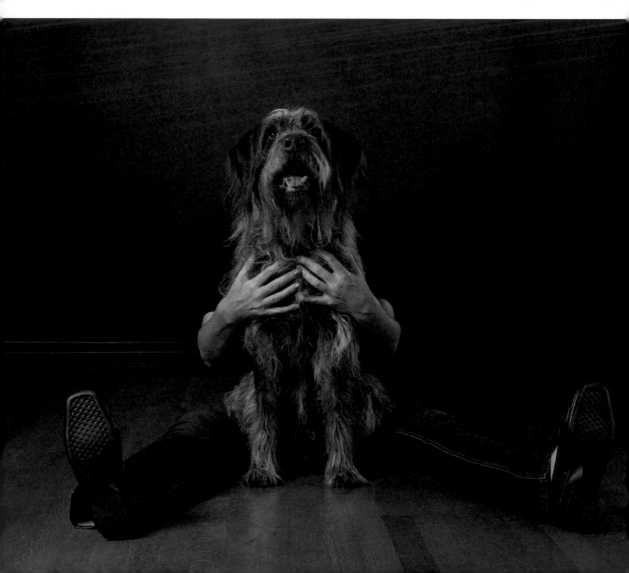

out on the couch and rest his head on my knee while I scratch under his ears.

The dog I didn't want turned out to be the dog I can't imagine living my life without.

P.S. It turns out that Udo is an American Wirehaired Pointing Griffon. Who says you can't find purebreds in rescue?"

"Who says you can't find purebreds in rescue?"

● Evie

"When we adopted Evie, we had recently lost one of the most special dogs we will ever own. We were heartbroken, and I knew I wanted an older, calm, 'grandma' dog to add to our house. I thought a slower, sweet, female dog would do the trick to mend our broken hearts.

A friend in rescue directed us to a video of a gentle, older female dog who had been abandoned in a backyard after her elderly owner passed away. I immediately wanted to meet her.

Over the months, her personality has blossomed. She doesn't have a mean bone in her body. She loves food and treats and always falls asleep in the craziest positions.

We know Evie is right where she is supposed to be. We only wish he had found her sooner!"

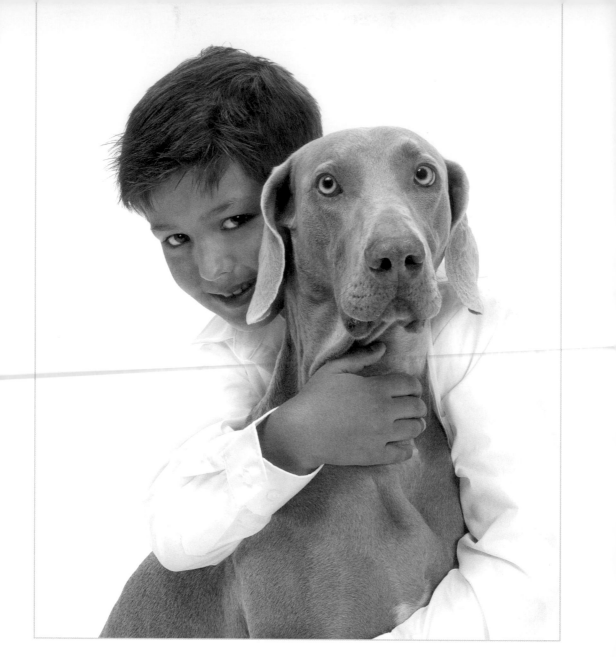

● Orley

"Sometimes the best things come in *big* packages. This guy, with his larger-than-life personality, came to us when we least expected it. He made us foster failures, but we have never been so happy to fail at anything.

Orley is a handsome boy, but his personality is too much for most people. We kept him while his foster family was on vacation, and we fell in love with the big goof. He is sweet and loving, and makes us laugh every day.

Orley has a couple of acres to run on. He alternates between hunting and taking power naps. With so much to do, he rarely gets into trouble anymore. We can't imagine life without our big, handsome boy."

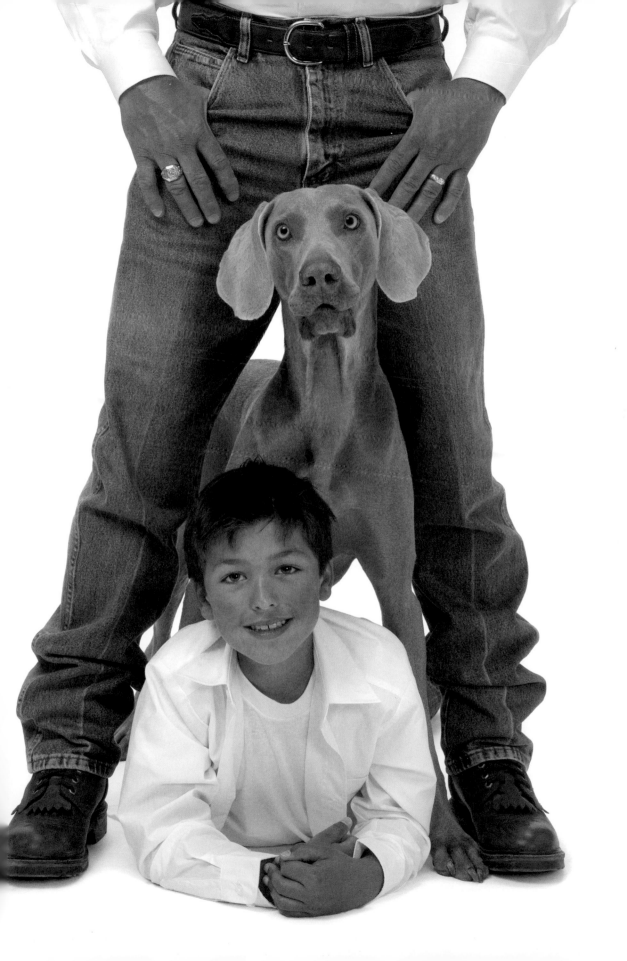

● Biscuit

"I found Biscuit outside of a store, where someone had tossed him out of a car. He was only about eight weeks old and was covered in fleas. It was really hot that day. When I pulled up, he was running back and forth under the cars. I picked him up and took him inside. I asked the ladies who worked there if they knew anything about the dog, and they told me he was thrown out and that they had been feeding him biscuits and water. That's how he got his name. He loves biscuits and is very fond of food.

Biscuit was the cutest little black puppy! He's very sweet. He might be a throw-away to some people, but he is so much more than that to me."

● Beatrice

"Beatrice, a Chihuahua, was once homeless. She was 17 years old when her original owner fell terminally ill and surrendered her to rescue. Her foster family kept her safe until we volunteered to adopt her. We were a good fit for each other.

The first few weeks were a bit rocky, as Bea taught us her ways. She rejected the dog door, preferring the personal service administered after her one bark requesting egress or access.

We have a pack of four now: three Boston Terriers and Bea. Bea is home. Her happy prance greets us when we return from outings. She shows us her 'cheese dance' when we offer her grated cheddar. She is safe, warm, and loved. But it is we who have been given the greatest gift."

"The first few weeks were a bit rocky, as Bea taught us her ways. She rejected the dog door, preferring personal service . . ."

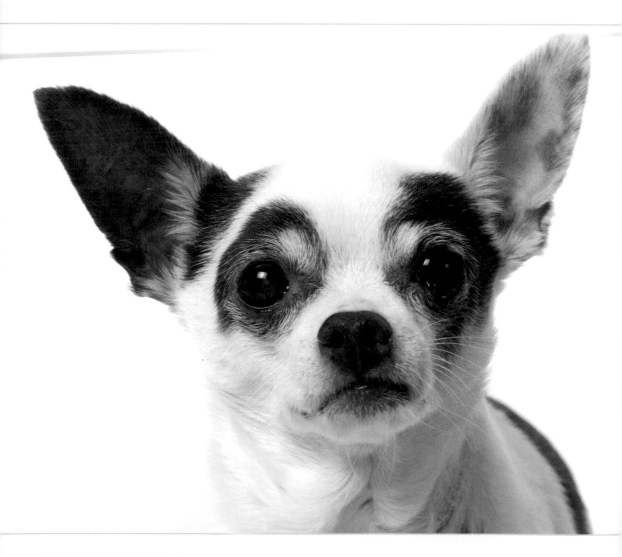

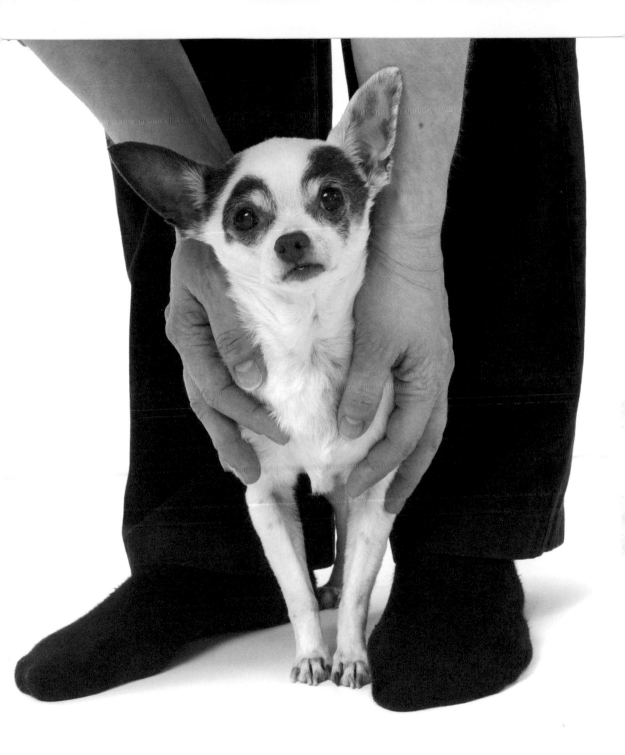

● Doodlebug

"Early one morning, a brown puppy was found lying and shivering in our front yard with a car-towing chain tethered to her skinny neck by a bit of twisted chicken wire. My neighbor and I tried to give her some food, but she got up and dragged the rest of the thick iron chain to keep her distance from us. Several neighbors worked together to approach her, and finally, the puppy collapsed.

We sat with her, fed her, unwound the wire, unlocked the two heavy iron hooks, and took the chain off her. She was covered in fleas and ticks, and her skin looked like a piece of torn rag. She had tiny wounds all over her legs, and her right eye and face were swollen.

I skipped work and rushed her to a clinic. We needed to get her well and find her a good home. My husband named her 'Doo-Doo' because it was what she looked like. After the clinic visit, she slept nonstop for two days.

The dog was very afraid of people. It took over 10 months for her to overcome her fear of the men who take care of her.

As time wore on, my husband renamed her Doodlebug. She is part of the family now. We have been rewarded in having a chance to take an amazing journey with a dog who went from looking like doo-doo to being our carefree Doodlebug!"

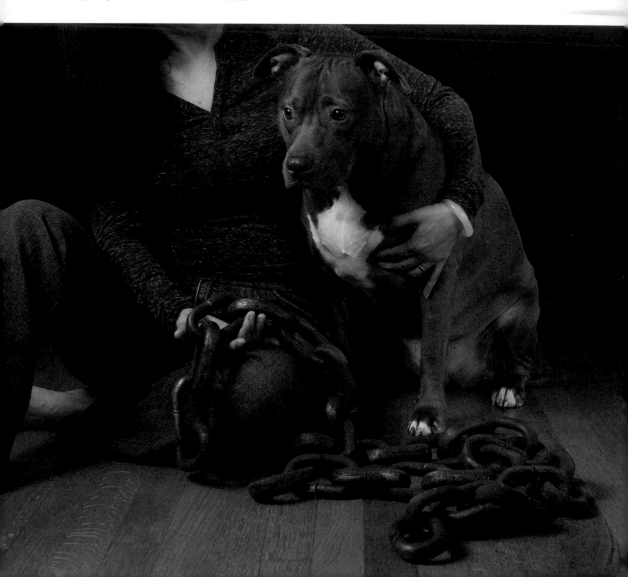

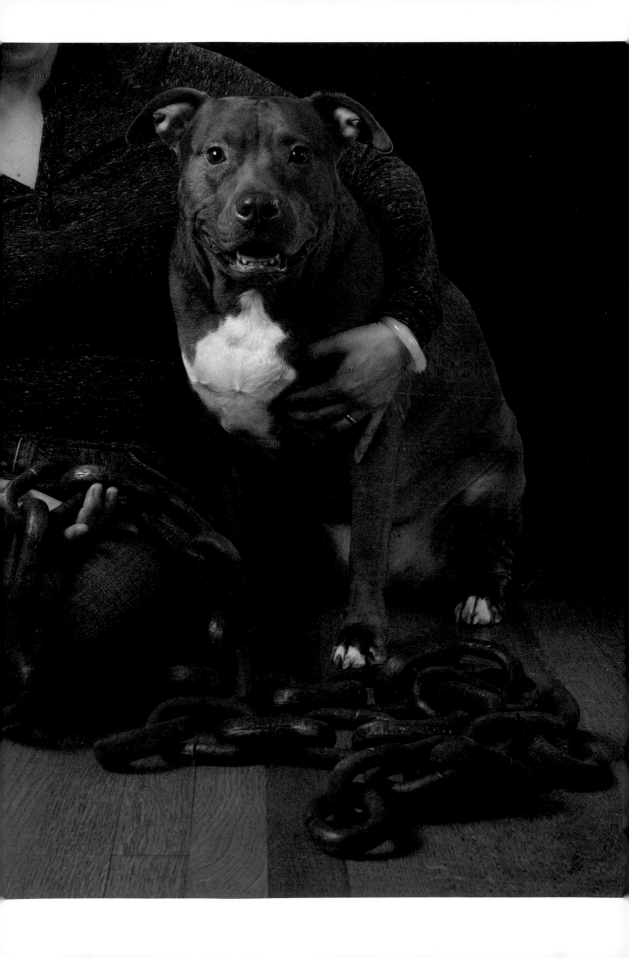

● Ruby

"Ruby was a street dog in a very bad part of town. She was bred a lot, and her puppies were taken from her for what I imagine was something horrible. She was left to starve and fend for herself.

During this time in her life, I didn't know her. But I followed her story from a woman who was trying to rescue her latest litter of puppies. I checked the blog posts on 'mama dog' and her puppies daily. The puppies were rescued, but the rescuers were unable to gain the trust of 'mama dog' to capture her. After some time, she was finally rescued and was safe and off the streets. I didn't give her a second thought.

Months later, when I was ready to introduce another dog into my family, I became interested in a particular dog that was available for adoption. In talking with the foster mom, it became apparent that this dog was the 'mama dog' I had been following all those months ago. I knew right then that Ruby was meant to be with me.

Ruby's past wasn't good, and I will never know all of the things that happened to her, but she is the sweetest dog, though she has every reason not to be. She has scars all over her body. She would have horrible nightmares and cried in her sleep. It took her a long time to be playful. But her past is now behind her, and she is a happy, joyful dog. She is an incredible example of resilience and survival. She inspires me every day."

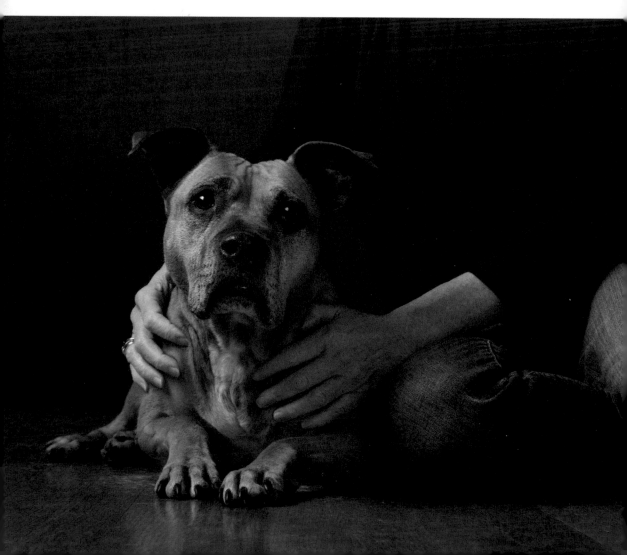

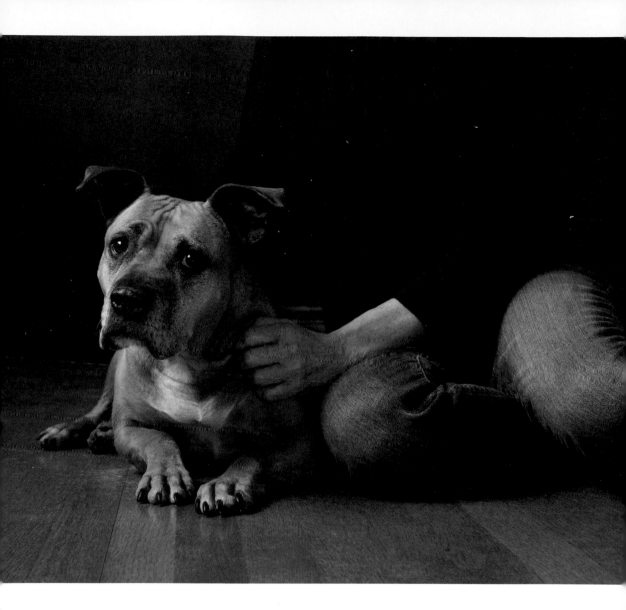

"Her past is now behind her and she is a happy, joyful dog. She is an incredible example of resilience and survival. She inspires me every day."

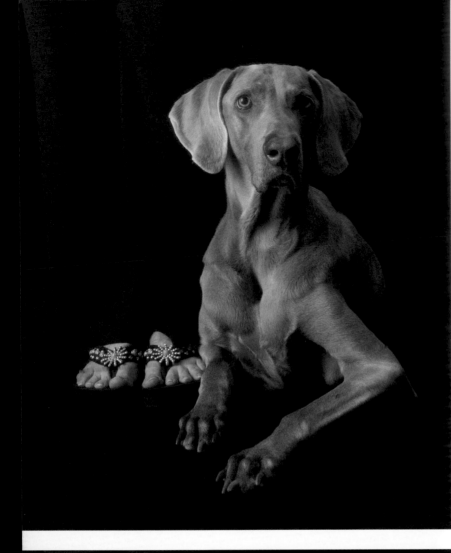

● Taylor Bones

"Taylor Bones was picked up by the side of the road, and her rescuer thought she was dead. Taylor struggled to her feet and accepted some water. She weighed only 48 pounds and had every disease and parasite known to dogs. You could see almost every bone in her body, and she had almost no fur. I fostered her and nursed her back to health.

Taylor is a lovely soul with a wonderful expression in her eyes. We decided to adopt her.

I have fostered dozens of dogs over my 20 years in rescue, but I have never known a Weimaraner with a sweeter temperament than that of Miss Taylor Bones. Her lovely personality and loving ways win all hearts."

"Her lovely personality and loving ways win all hearts."

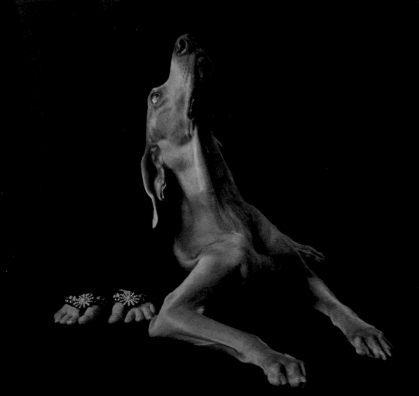

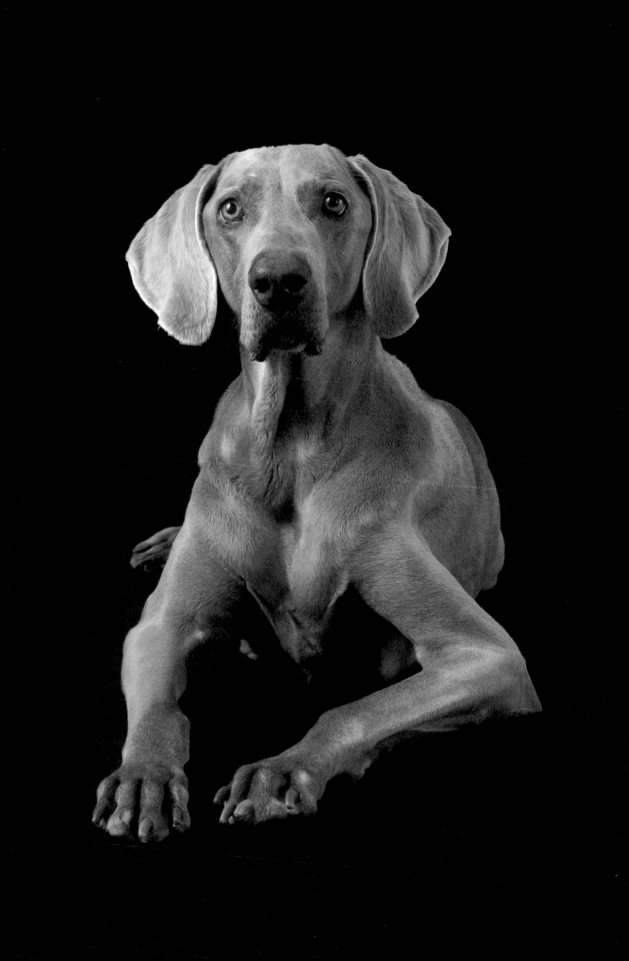

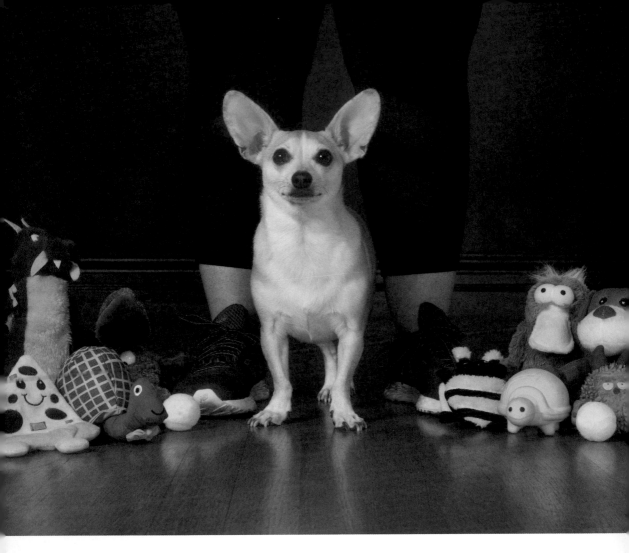

● Dale

"Dale suffered a traumatic brain injury when he was around eight weeks old. He was surrendered to the local shelter when his original owners were overwhelmed by his condition. The shelter got him to a Chihuahua rescue.

I was working as a vet tech in a clinic and had a coworker who worked with a Chihuahua rescue. Dale was brought into the clinic, and I fell in love with him. He and my previously adopted dog completely fell for each other. She helped teach Dale how to be a dog again.

It took a few days to get him walking again, and six months for him to figure out how to run once more. By then, we decided he needed to be ours.

Dale makes us laugh 100 times a day. He is so funny and silly. He loves to play fetch and cuddle under blankets. He loves ice cubes! He puts a smile on the face of everyone he meets. He makes our little rescued family of two dogs, a misfit cat, and an old tortoise complete. He is joy in our lives, and will be forever referred to as 'the baby.'"

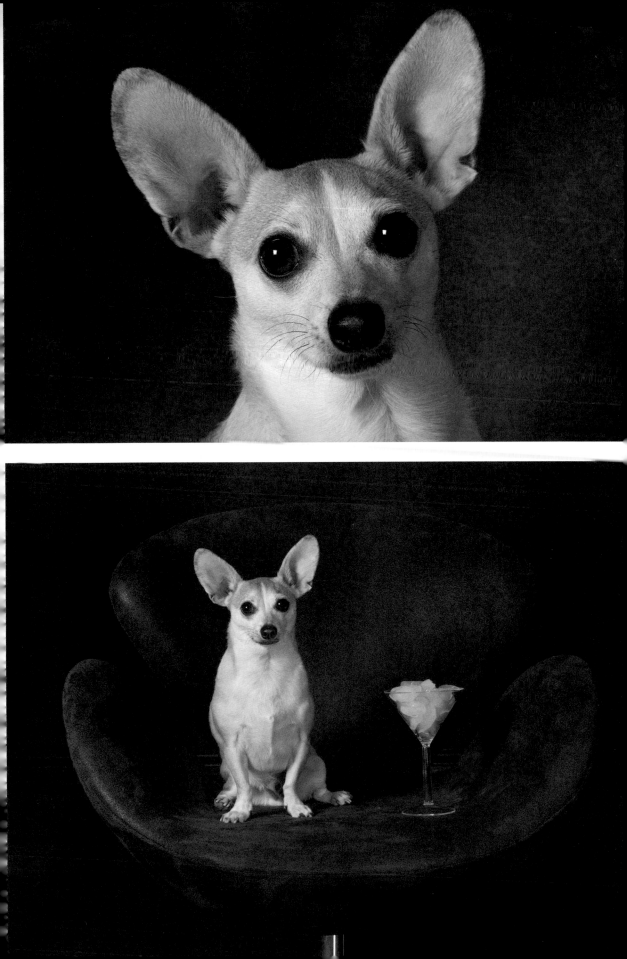

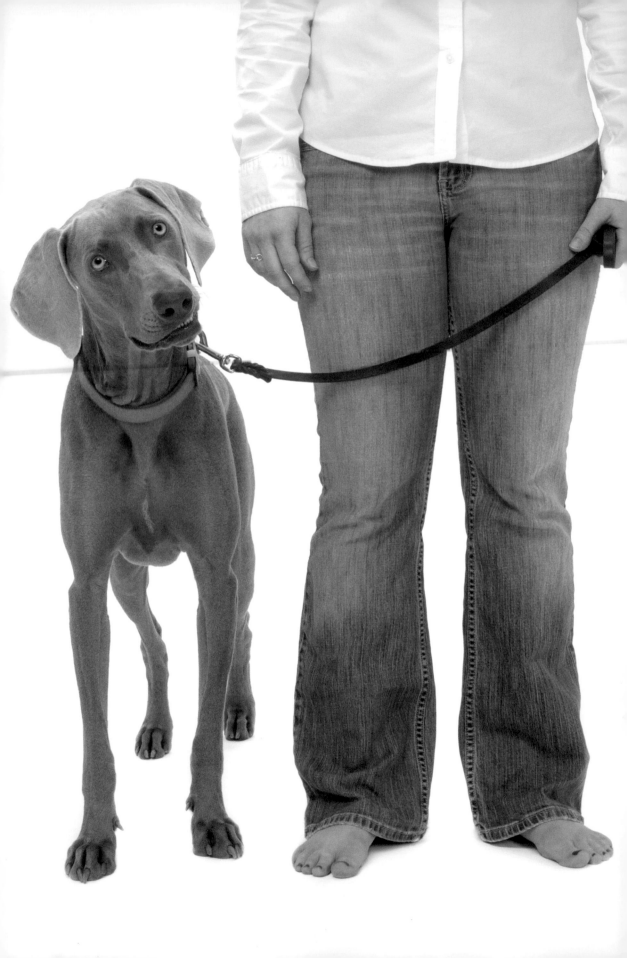

● Olive

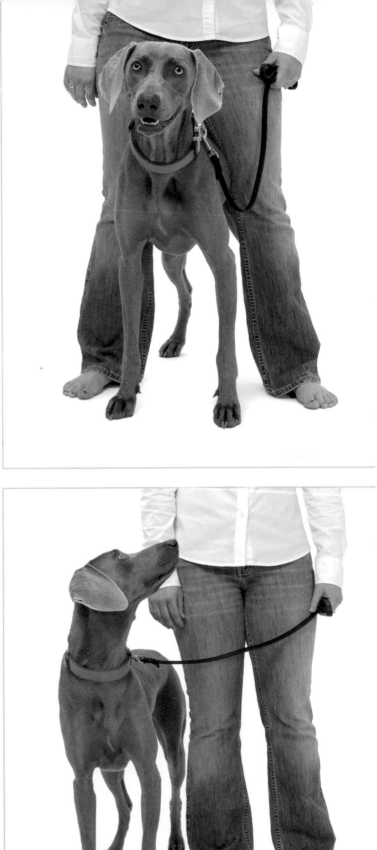

"Olive was around eight weeks of age when she was brought into the police department with her sister. It is thought that the pups came from a backyard breeder who couldn't sell the last of the litter.

Olive was skin and bones. We offered to foster her with the thought that maybe this was our next family member. After fostering her for only a few days, our hearts were hers!

Olive is such a wonderful part of our family, constantly making us laugh at her antics and wanting to be in the same room with us. I don't think she knows she was adopted, since she was so young when she came to us. She probably thinks this is just where she has always belonged."

"She probably thinks this is just where she has always belonged."

● Scooter

"Scooter was an owner surrender—but not your typical owner surrender. His owner was a trucker who was also a military veteran. By an awful twist of fate, the man lost his job and home. Having no other choice, he was forced into a homeless shelter, but could not take his dog. He was in tears as he entered the pet store and asked if we were a no-kill rescue and if we could take his dog. Of course we could help. All of the rescue volunteers were crying, so we accepted Scooter and promised to do our best to find him a new home.

We took him to events and tried to adopt him out, but there was little interest. Scooter didn't care for most folks, but for some reason, he took to me. One warm day, we decided to set up in front of the pet store rather than inside.

I was talking with a family about a dog when a small boy touched my arm and said, 'Miss . . . look!' He pointed down, and there was Scooter, sitting at my feet! Somehow, he'd gotten out of his crate and rather than running into traffic, he ran to me.

After a few more attempts at adoption events, it was clear that Scooter belonged with me. A walk through our house guarantees that you will see a Chihuahua attached to my ankle. I am greeted by his beautiful face and pointed ears every time I come home. Knowing he is there makes any bad day a good one.

What an honor it is to care for a veteran's friend, and have Scooter's love and trust in me."

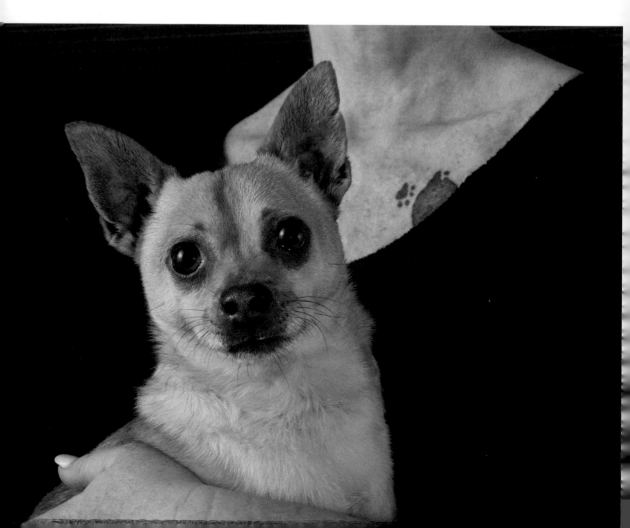

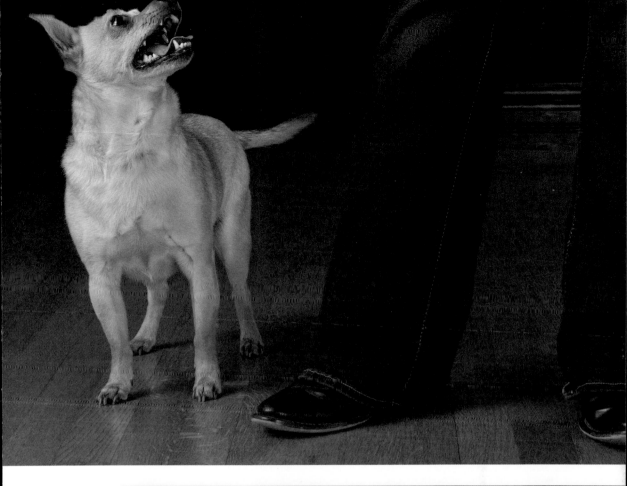
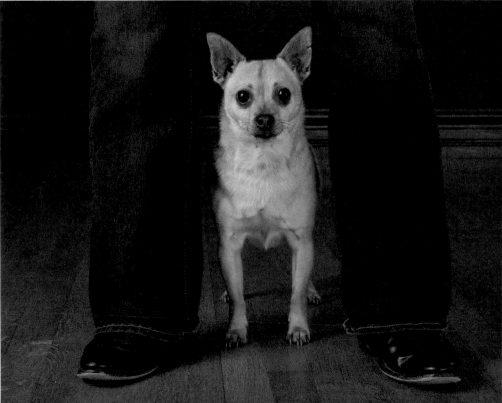

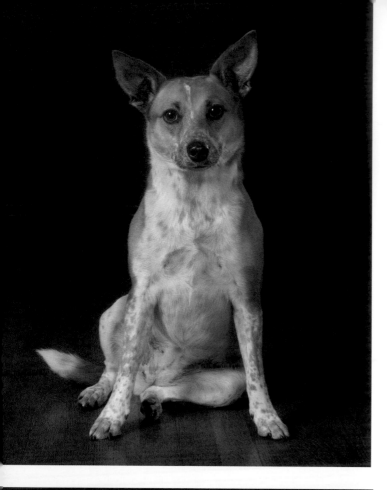

● Ginger and Libby

"Libby and Ginger were four months old when I found them living under a bridge and starving. They were pretty much feral. A friend helped me catch them. She and I both ended up face down in the mud a couple of times, but we were determined to corral them. Chicken fried steak works wonders in times like these!

We took the pair to the vet, and he confirmed they were sisters. He said they were Queensland Heelers. I know they are some type of Heeler, because every morning, they nip at my feet and legs as I walk down the hall, making me walk faster to get their breakfast. Help! I need cattle!

Ginger *(left and following page)* is the smarter of the two. She likes to sit at the kitchen table a lot. Sometimes I think she's waiting for her morning coffee and newspaper.

"She likes to sit at the kitchen table a lot. Sometimes I think she's waiting for her morning coffee and newspaper."

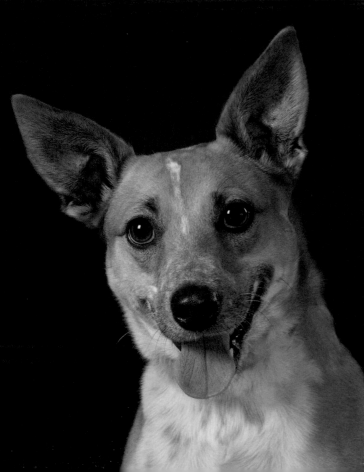

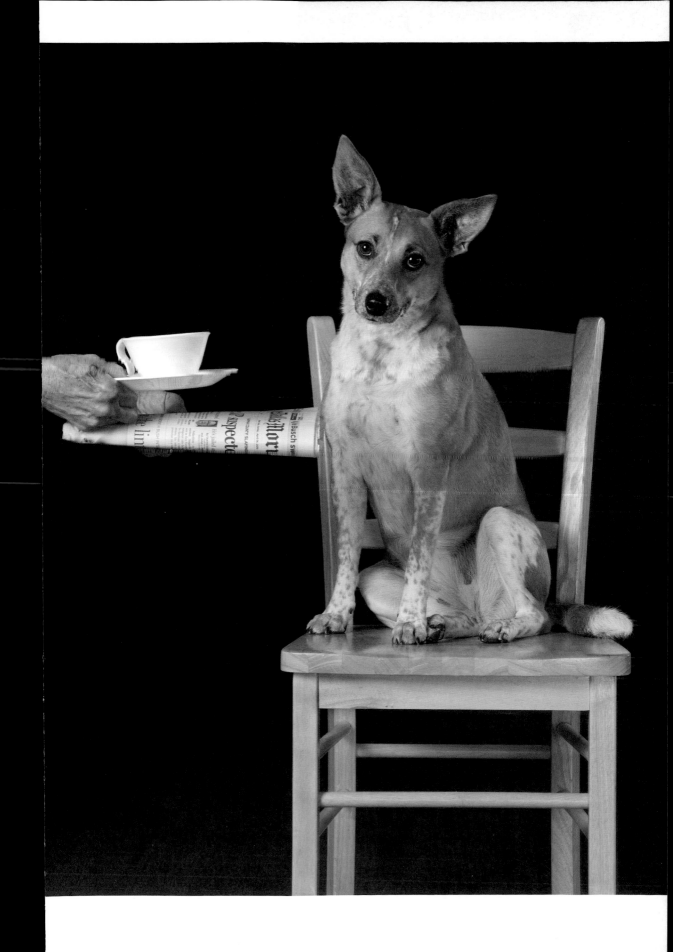

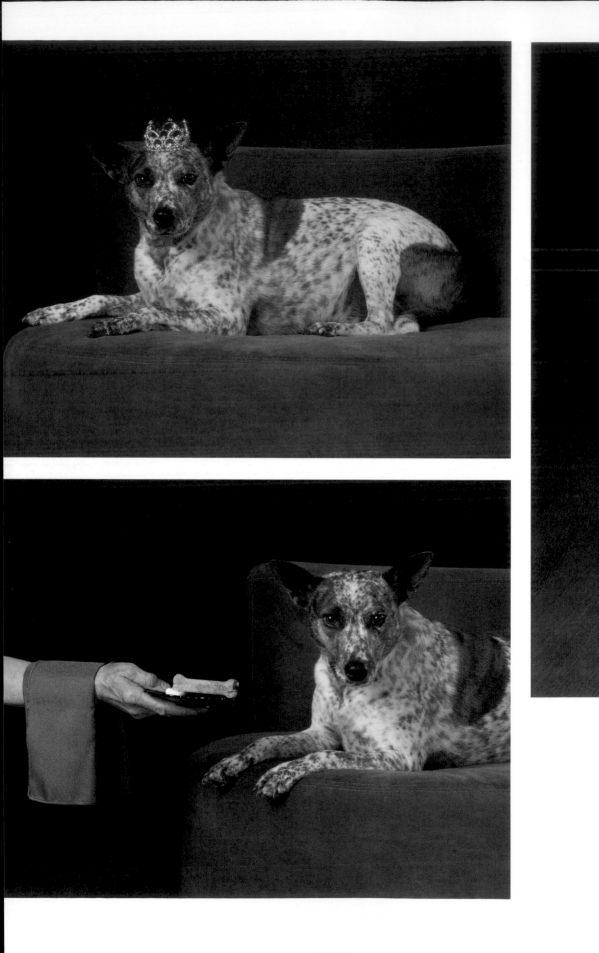

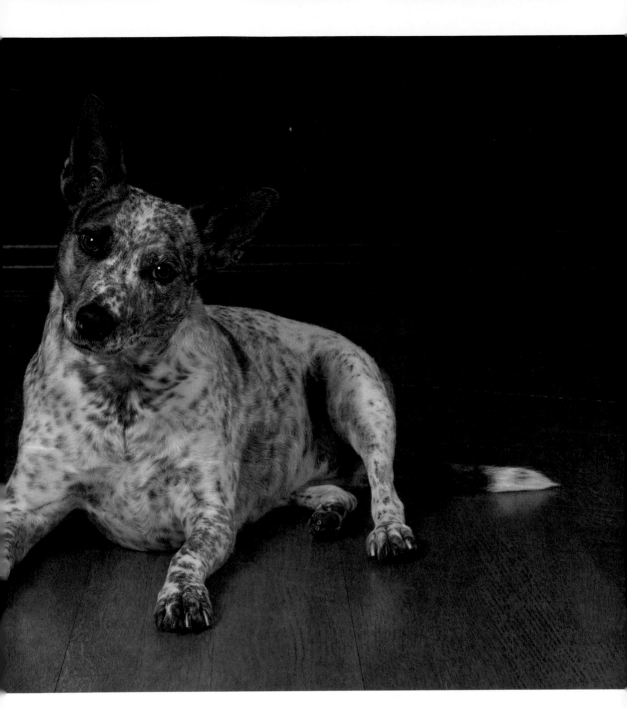

Libby *(previous page and above)* is very shy and laid back. A life of luxury is her thing. I think she is glad not to be living under a bridge anymore and appreciates having someone to love her and feed her.

Ginger loves food! It's hard to keep weight off when you are a couch potato.

My doggies don't possess any superpowers, nor will they ever pull anyone from a burning building, or win beauty contests, but they are my heroes. They keep me going and let me know that they will always love me, no matter what."

● Hilda

"Hilda was never supposed to be our dog. My 90-year-old mother wanted a canine companion and asked for the same breed we had when I was a child. The dog would be an adult female, red, smooth-coat, miniature Dachshund. I had no idea how tough she would be to find!

Then one day, I heard about a Doxie at a shelter who had been found alongside a rural road,

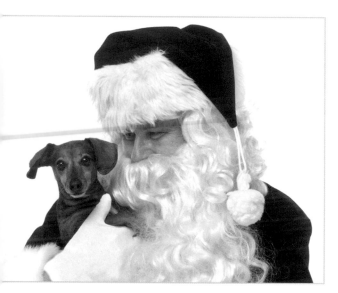

but hadn't been adopted within a week. My friend and I immediately skipped out of work to fetch the dog. Hilda had been spayed the day before, so she wasn't yet in the shelter's general population. When she was carried out to me, she looked around the room as a homecoming queen would wave to her subjects in a parade. I knew in that moment I had to take her home.

My friend and I drove to my house, and I handled Hilda to my husband without any ceremony. He fell in love within minutes. That night, we found out that Hilda had been crate trained, although she did not want to be there. She ended up in bed with us, and she has been my personal canine heating pad ever since.

After that first week of affection, we were totally her slaves. We couldn't give her up. But how to tell my elderly mother that we wanted to keep the dog we had gotten for her?

As it turns out, Hilda has too much strength and energy to be a good companion to my mother. In the end, we adopted a four-pound Maltese whose only desire in life was to sit in my mother's lap and be brushed and loved. Everyone is happy.

My husband is head-over-heels in love with Hilda. He makes short films with Hilda as the star. And every winter for our Christmas cards, he plays Santa Claus with Hilda. We truly can't imagine how sad is the life of a person who doesn't know a dog's love. Dogs ask for so little and give so much. Every day, we are very thankful for the joy that Hilda's little soul has given us."

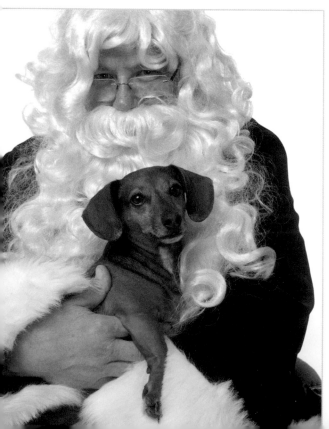

CANINE WISDOM

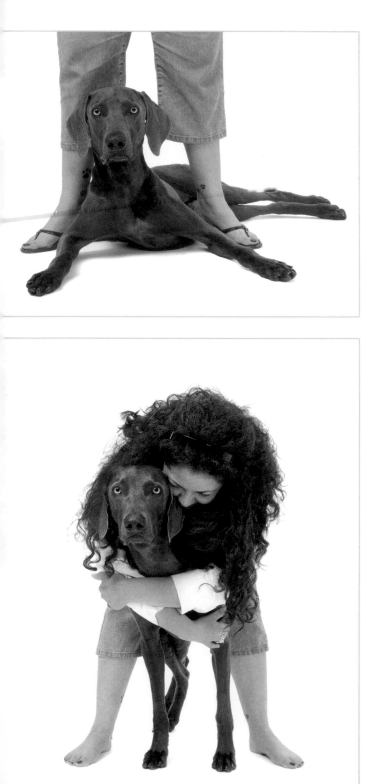

● Hank

"Hank came to me at a difficult time in my life. While on call for Weimaraner Rescue, I received a call about a blue Weimaraner who had been hit by a car. We found out he had not one, but two, broken legs. We went through three surgeries, casts, endless bandages, trips to the ER, pain medications, and more. It was a long healing process.

During all this, despite being in pain, Hank never looked scared and always had a great attitude.

When had he healed enough, I took him to meet and greets to find him a new home. People loved him, but he was not adopted. By then, we had been together for 10 months, and I knew he belonged with me.

I had been going through some difficult times while Hank was healing. We nurtured and took care of each other. I learned a lot from him. I learned not to feel sorry for myself and to be grateful. I learned to not take things too seriously and to be patient. We were there for each other. Hank would do something silly and make me laugh just when I really needed it. I am grateful for all of the strength and love he has given me."

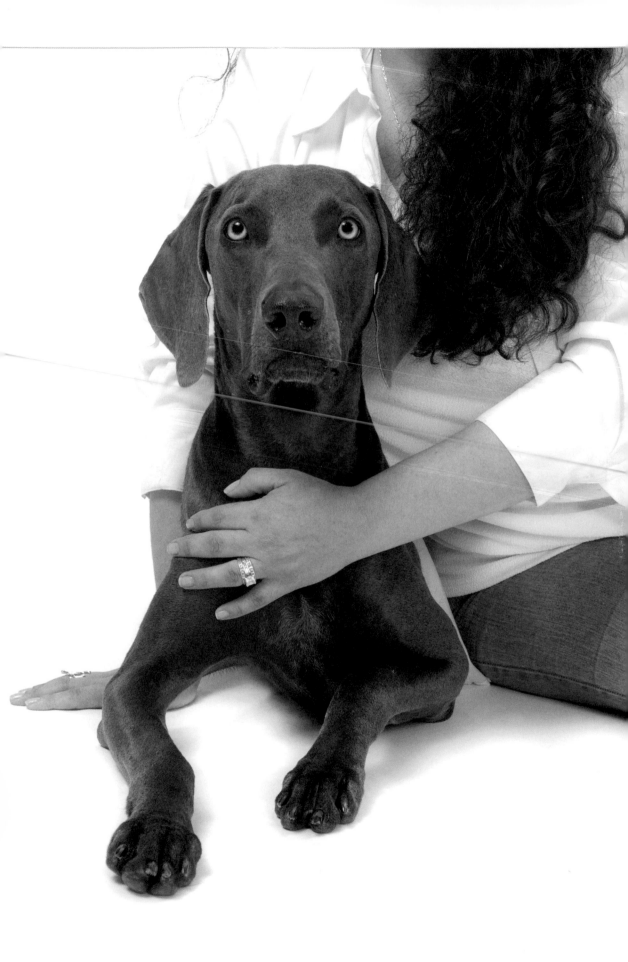

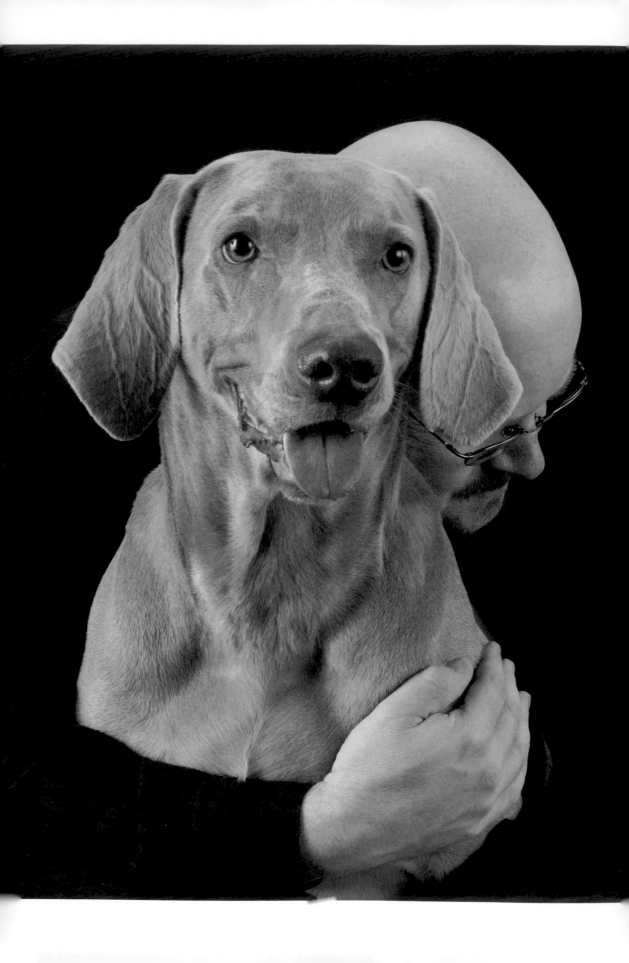

● Shiner Bark

"Shiner was a stray who came into our lives when he was just over a year old. At first, he was timid and unsure of his place in the world. But when I met him, he came straight up to me, sat, and nibbled at my goatee. In doing so, he captured my heart.

Shiner connected with me on a level I've never experienced with a dog. No dog I had while growing up was as dear or as dedicated a companion as Shiner. He's become the reluctant alpha in our pack of four dogs. I describe him best as a benevolent dictator.

He keeps me grounded and reminds me that the world revolves around tennis balls, fetch, and puppy treats. He protects my family and steals my covers. He's my buddy, my Shiny boy."

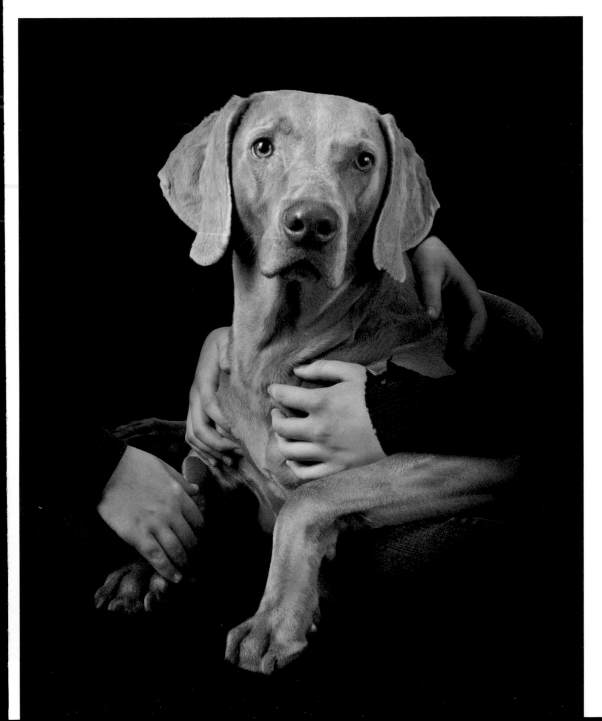

● Reed

"We decided we wanted to volunteer for Weimaraner Rescue, and the very day our application was processed, we were asked to foster a dog.

Reed was at our house the very next day. When he arrived, he was a bounding, barking, bundle of energy. After his first few days with us, he began to settle down a bit and show us his sweet-natured side. It wasn't until we brought him to a rescue event to get him some exposure that I realized I didn't want to give him up.

Reed is just so affectionate and has the capacity to be so incredibly sweet. I can't imagine my life without him now.

I see how content he is to be a part of the family. He knows he's where he's supposed to be now, and that we're not going to abandon him like his first two families did.

I'm constantly amazed at the capacity of animals that have been abandoned or abused to love humans unconditionally. Reed brings us so much joy, and we consider ourselves lucky to have him in our lives."

"He is just so affectionate and has the capacity to be so incredibly sweet . . ."

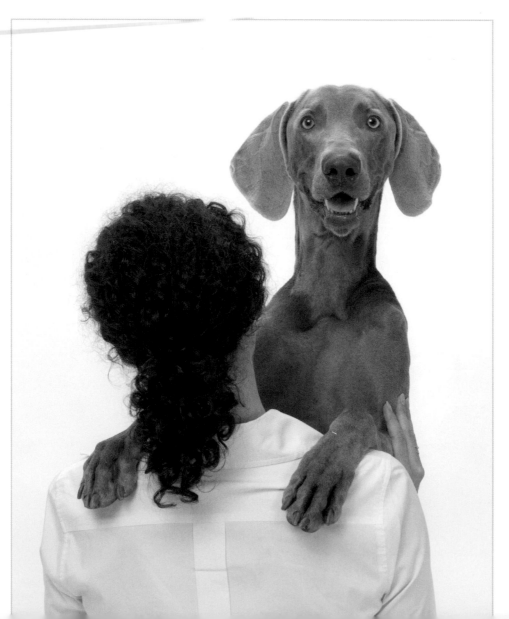

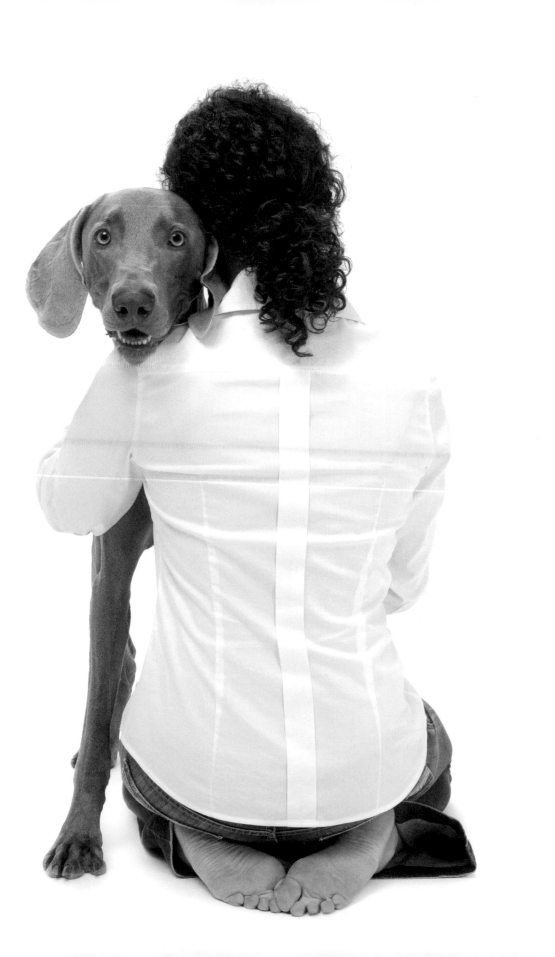

● Mr. Bingley

"In our years together, Mr. Bingley has helped me foster dozens of dogs. He has opened his home, bed, and couch so generously to these other dogs. Though he has preferred some foster dogs to others, he has never failed to graciously share my affection. I can only strive to be so welcoming and without judgment as he. Sometimes I miss the days when it was just he and I, and I'm certain he does, too, but in the end, he knows that he is, and always will be, my Mr. Bingley. He is the ambassador of rescue."

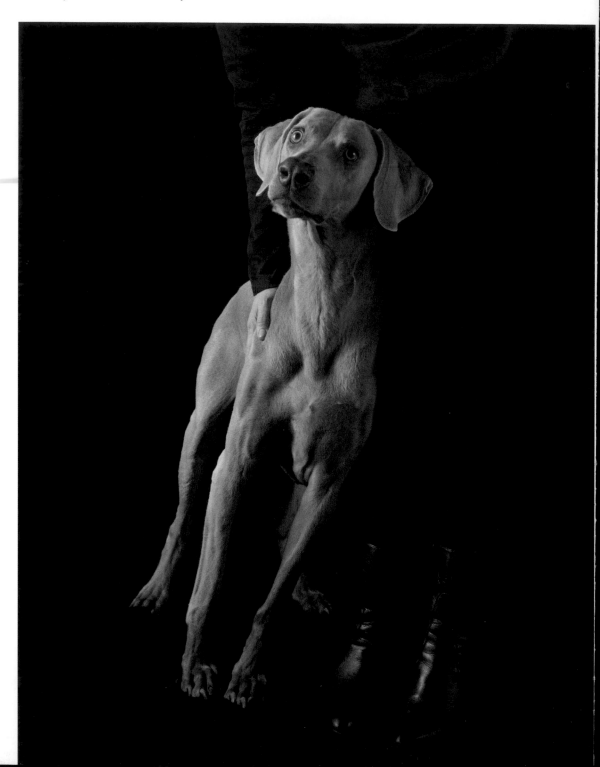

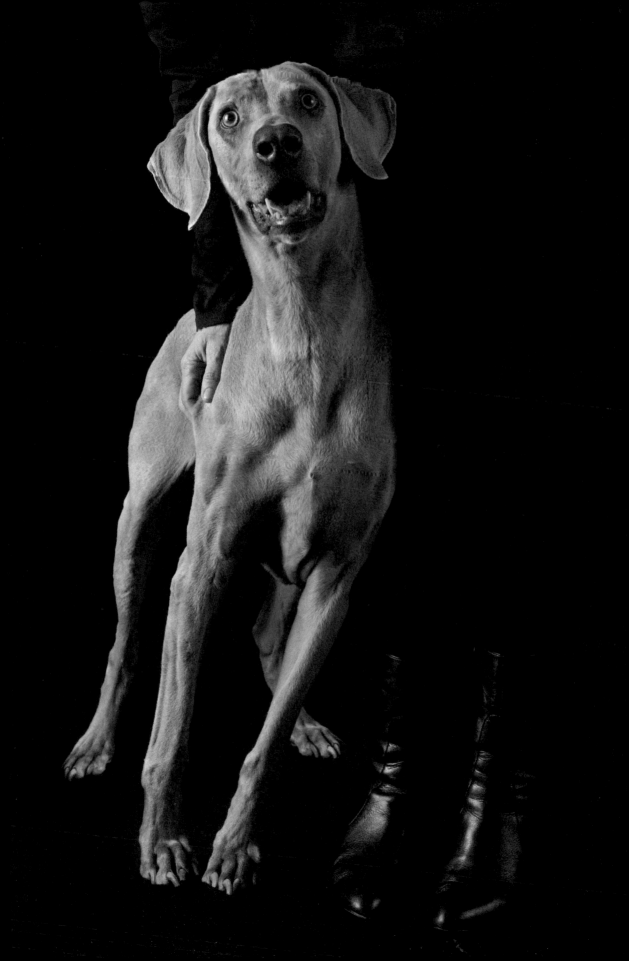

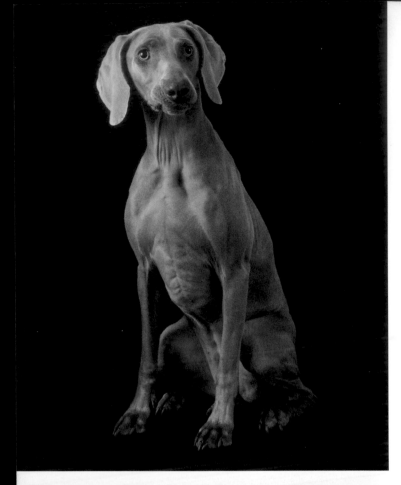

● Momo

"When Momo was adopted, she was extremely thin. She was anxious and did not like being alone. Since we adopted her, we have managed to put weight on her, and she is much better trained. She now loves sleeping in her crate every night with the door open. She likes to play with other dogs, but is also happy to curl up on the bed and snuggle with Mom.

Momo is going to become a big sister to a human baby, and she has helped us to prepare for parenthood. She taught us patience, endless love, and how to deal with a messy house. We cannot wait to take Momo and our little girl out for walks. Momo is going to be a wonderful big 'sister.'"

"Momo is going to become a big sister to a human baby, and she has helped us to prepare for parenthood."

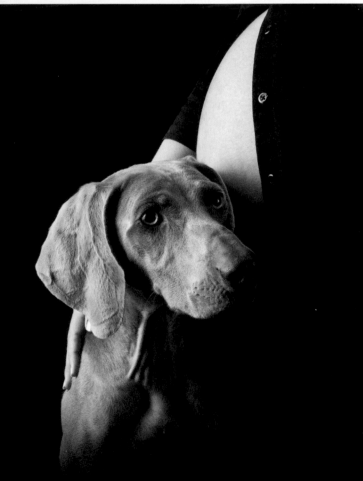

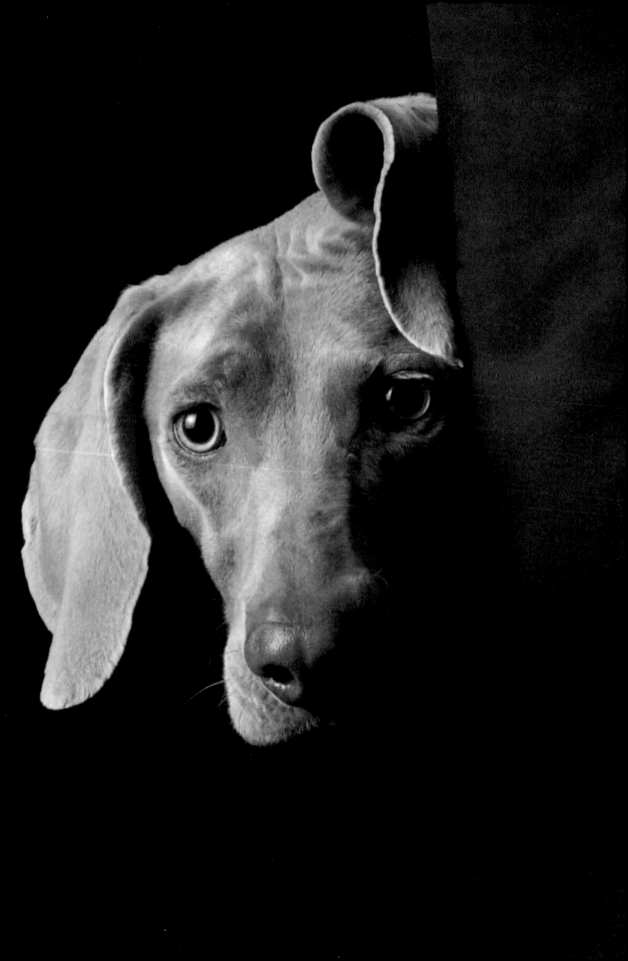

SNUGGLE BUNNIES

● Liesl

"We had been looking for a new dog for about a month. We'd checked out several of the rescue sites, but had not found a good match.

The following week, I had to go to Las Vegas for a work conference. While I was there, a young, blue, female Weimaraner popped up on one of the sites that we'd checked the weekend before. In the evenings, I sent emails to try to get as much information on her as possible. We decided she would be a good match.

We named her Liesl. She is a full-blooded Weimaraner who was found running free. She was housebroken and micro-chipped before being taken in by the rescue group. Our theory is that she was a Christmas gift, and then the cute puppy became a typical high-energy Weimaraner and was discarded.

Several attempts were made to contact her original owners, but no response was received. Their loss is our gain.

Liesl is close to 70 pounds now, and, as tall as she is, she still thinks of herself as a lap dog. I work from home, and if I am sitting in my recliner, working, it is not uncommon for her to crawl up into my lap to sleep. Once she gets settled, she is there for a while, so it is imperative that all food and bathroom runs are completed before she gets settled.

I never thought we would have a 70-pound lap dog, but I'm so glad that we do."

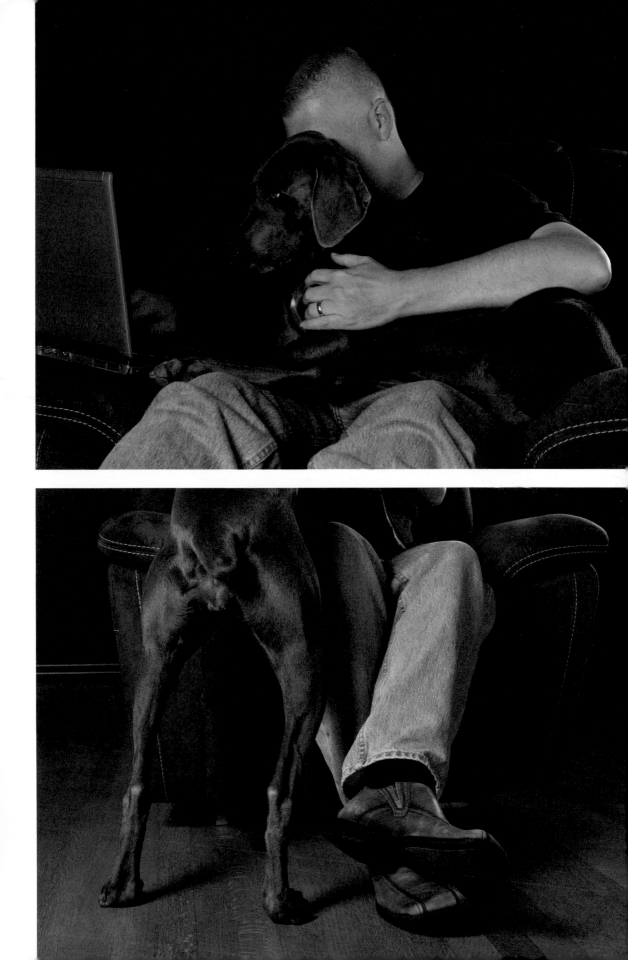

● Peanut

"Peanut came to the local shelter as an owner surrender. When asked about the injury to his right rear leg, the owners said he had been bitten by a spider. The shelter was able to find a rescue group to handle a special-needs dog, and I was asked to be his foster.

The first thing was to get him a vet examination. The vet was appalled by what she saw on the x-rays. This was *not* a spider bite! This poor dog had eight breaks in his leg, two of which were compound fractures. After a couple of fund-raisers and donations, Peanut had surgery and recovery at my house.

Once he was fully healed, I took him to an adoption event, and he immediately got the attention of many people. One woman asked for an adoption form for Peanut, but was told that the group had already received an application, and it looked good for an adoption. Little did I know that the rescue group wanted to give the dog to me! I was thankful and honored. This little boy would be mine forever.

Peanut is a wonderful foot warmer at night. He's such a snuggler and loves to burrow in his soft quilt on the sofa.

The unconditional love and trust of this amazing dog touches our hearts. He teaches us what true love and trust are every day of his life."

"The unconditional love and trust of this amazing dog touches our hearts."

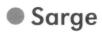 Sarge

"Sarge came from a rescue group. He filled the hole left by the passing of our previous dog. It is a joy to watch him roll in the grass, ask for a hug, howl at a siren, or cradle his head in my lap. He has made our family complete."

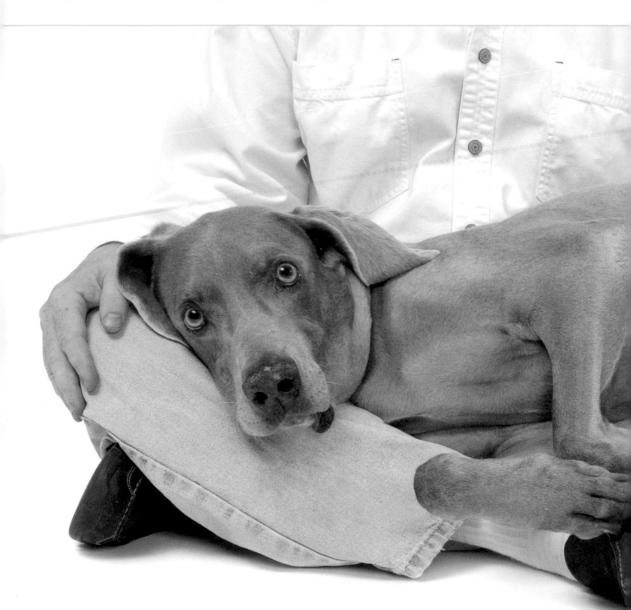

"It is a joy to watch him roll in the grass, ask for a hug, howl at a siren, or cradle his head in my lap."

● Tobie

"Tobie was found alone on a dark road in the country around midnight. We picked him up and went to our weekend cabin, which is located nearby.

Our two teenage daughters said the dog was a boy, and they named him 'Toby.' It wasn't until morning that we realized the dog was a girl, and we changed her name to 'Tobie.'

Tobie enjoys going to the weekend cabin and jumps into the truck and crawls under the back seat. She loves the outdoors. Even better, she adores her blanket. She loves being covered in it when she sleeps. She likes to play a game with the blanket. It covers her head, and we poke at her through the blanket. She tries to grab your fingers. It is so much fun.

A lost dog found on a lonely, dark, country road found a family to snuggle with, and everything is forever changed."

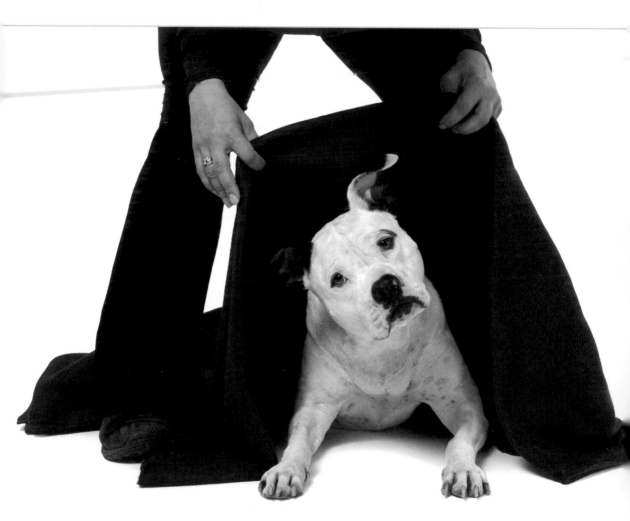

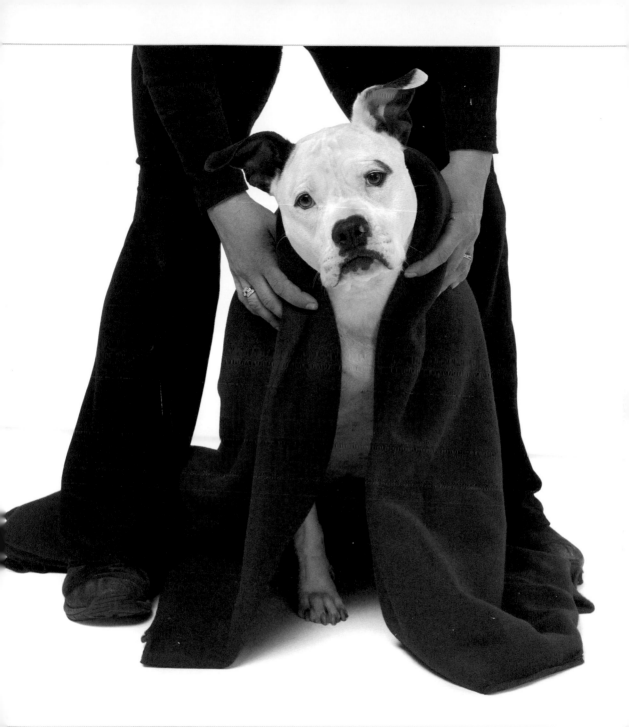

A lost dog found on a lonely, dark, country road found a family to snuggle with, and everything is forever changed."

● Addie

"Addie was rescued from a puppy mill. When I first saw her, I couldn't resist her big, olive eyes, and the one ear that flopped a bit more than the other. She had heartworm from being neglected, and I was eager to take care of her and nurse her back to health. My life has not been the same since.

Addie gives more to me than I ever imagined a dog could. She listens to me, makes me laugh constantly, and has been a great running companion. She doesn't understand the concept of 'catch' and is afraid of big trees. Addie thinks she is a lap dog—a 60-pound lap dog, at that! In the evening, she crawls onto my lap as I sit on the floor and falls asleep. She gives more to me than I ever imagined a dog could give. She has brought so much happiness and laughter to my life, and I couldn't imagine life without her."

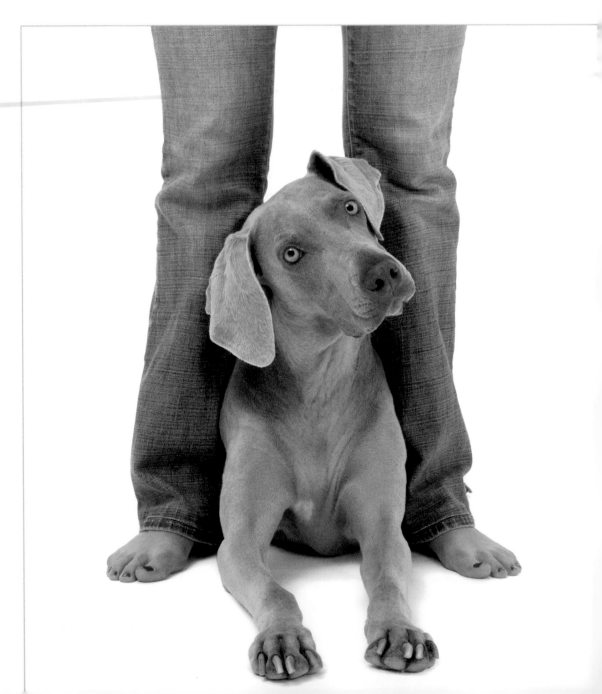

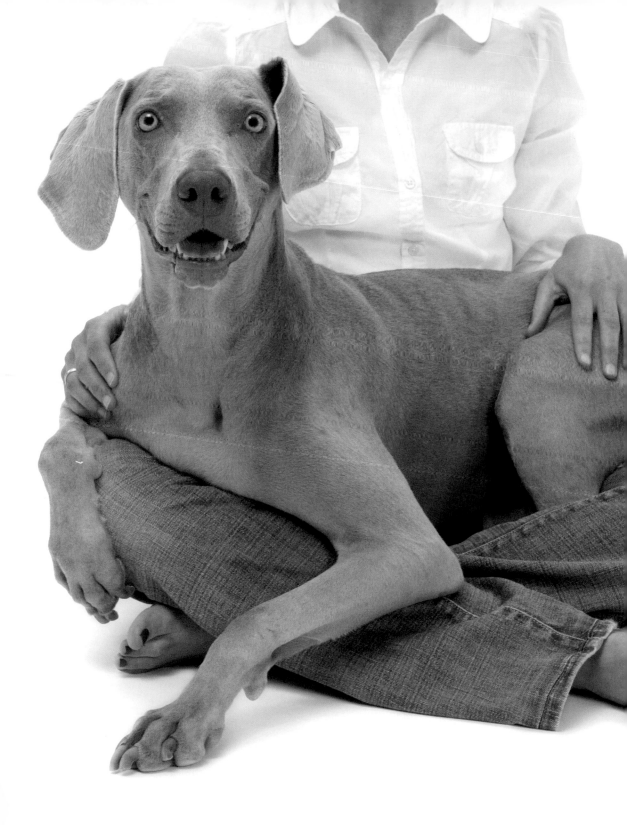

OUR GUARDIANS

● Abigail

"Abigail is a beautiful, gentle, and loving blue Pit Bull mix. Dark Pit Bulls are some of the most-often euthanized shelter dogs. True to type, Abigail was scheduled for euthanasia not once, but seven times. She was spared each time. Finally, a rescue group was able to take her in and get her adopted.

Abigail is gentle and quiet. Her past has left her a little scarred. She's afraid of the dark, scared of loud noises, and terrified of Tejano music. She has nightmares, but a cuddle makes them go away.

Abigail loves her family. She was the first to know that something was wrong with our teenager. She started growling at him from time to time. Sometimes it was a quiet growl, and other times, it was loud. This worried us, as we didn't know what was going on. It all became clear after our teen was hospitalized and diagnosed with type-one diabetes. We learned that the growl was Abigail's way of telling us that our son was in a danger zone. She knows when his blood sugar is dangerously high or dangerously low, and makes sure we take care of him. She is truly a blessing to all of us. I am so grateful to my angel for watching out for my son."

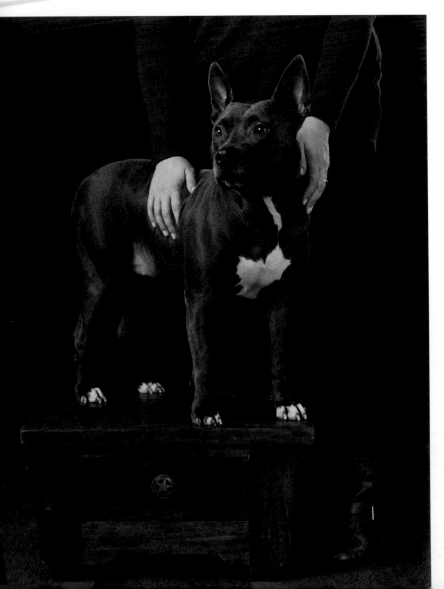

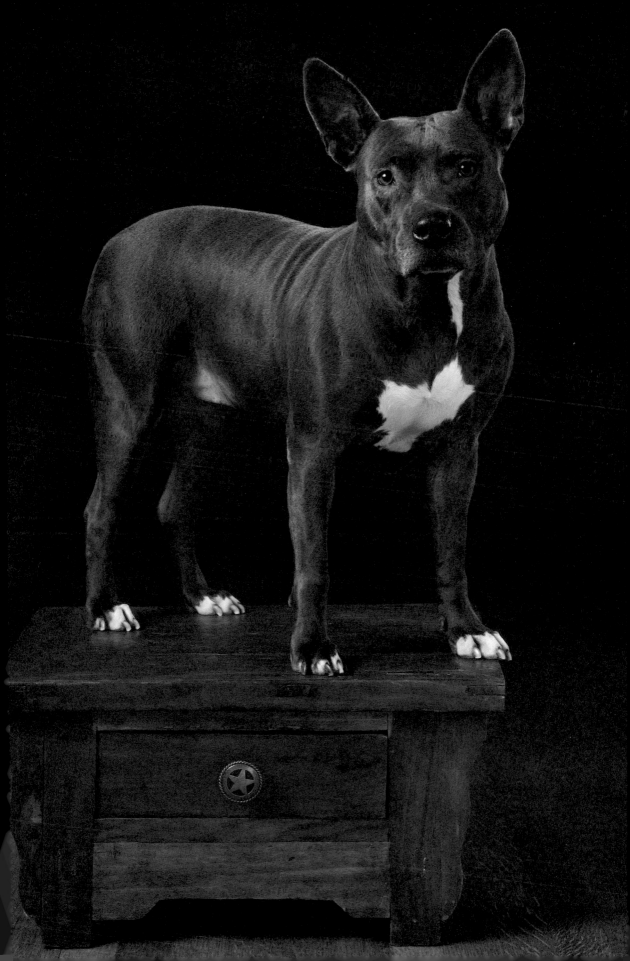

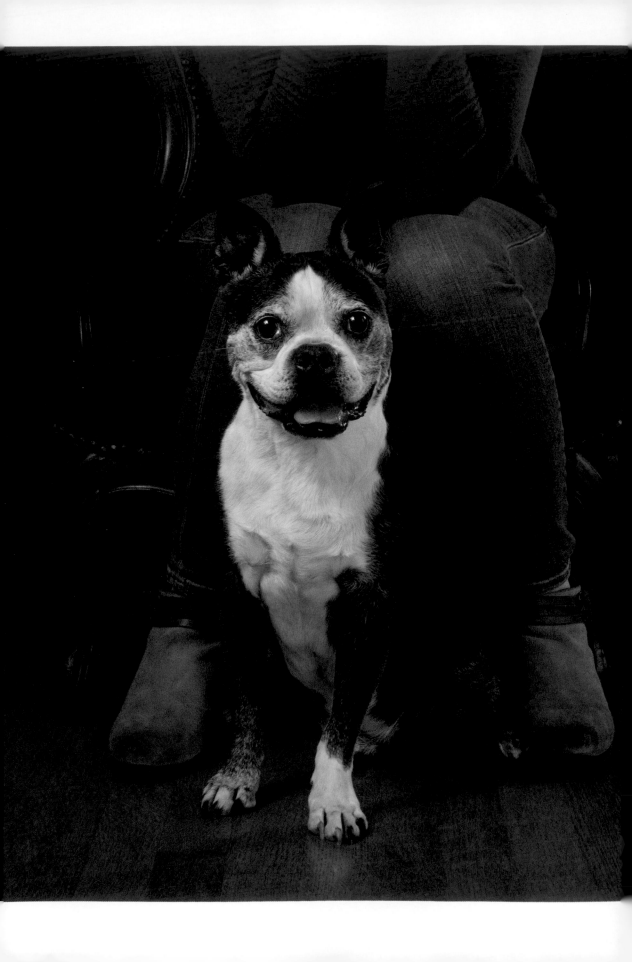

● Dudley

"Dudley was found roaming a parking lot. He was malnourished, scared, and had a chain padlocked and wrapped around his body. The chain had dug into his neck. He was captured, and a vet took care of him.

They tried to find his owners with no success. He was set to be euthanized when my aunt called and asked if I wanted a dog. I knew I wanted him as soon as I heard his story.

The first time I met Dudley is a day I'll never forget. My aunt had a chain-link fence, and when I walked up to it, Dudley jumped over it and directly into my arms. He kissed my face, wiggled his body, and wagged his tiny tail. He snuggled with me the whole weekend and barely left my side. We are now inseparable.

I know I rescued Dudley, but Dudley also rescued me. When I got him, I had been recently diagnosed with Multiple Sclerosis. I was sick, exhausted, and absolutely terrified. He would sit on the couch with me for hours after my treatments, and on days when I didn't have the energy to do anything. He made me smile and constantly had me laughing. It's hard not to laugh with a dog sitting in your lap, licking your face. He's the perfect dog for me!"

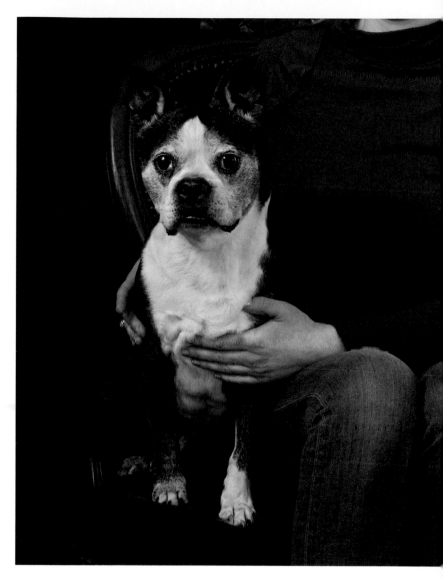

"It's hard not to laugh with a dog sitting in your lap, licking your face."

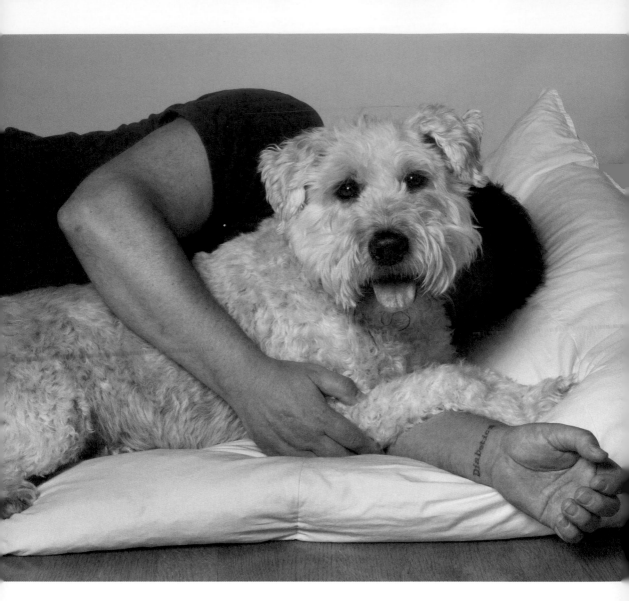

● Darby

"Darby came into my life from a no-kill shelter. I had gone there to make a donation in memory of my dog, who had passed away the day before. I walked through the kennels, and Darby was

"I have been a type-one diabetic since I was a child. Darby has learned to alert me when my blood sugar drops."

in the last one. He was the same breed as my former dog. It had to be a sign. He was healing from deep scars from a rope that was around his neck and many other injuries, including a broken leg. I knew he was coming home with me.

I have been a type-one diabetic since I was a child. Darby has learned to alert me when my blood sugar drops. He whimpers at night to wake me up from my sleep to get me to test my blood. He has been right.

Darby has become quite the snuggler, and he is very protective. I depend on him, and I love seeing him and loving him. He greets me when I come home after work, wagging his tail, wanting to lick my forehead. He enjoys his walks, car rides, and having his belly rubbed. He loves sleeping on his back with his feet in my face. He is my baby. He is my Darby."

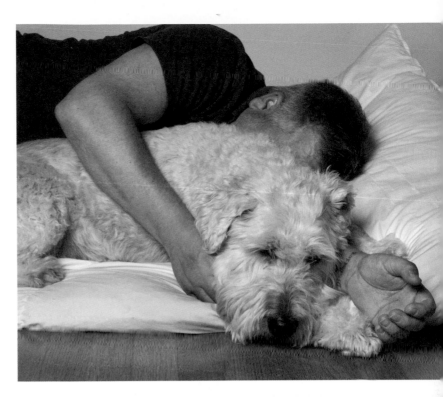

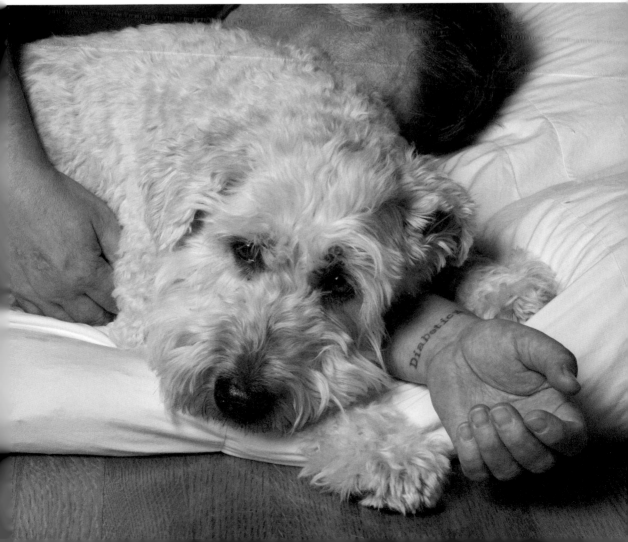

 # Will

"Will was barely one year old when we adopted him from rescue. We were his fifth family. His first owners surrendered him because they couldn't handle him. His first foster family gave him up because they couldn't handle him. His second foster was a good match. His first adoption returned him, and then we adopted him.

Will was hyperactive, jumped on people, was a counter surfer, and had the attention span of a gnat. He barely stood still and loved to run. He is not the smartest dog we have had, but he makes up for it in other ways. He has a heart of gold, loves everyone, and has never met a stranger.

After adopting Will, we became rescue volunteers and started fostering dogs. Will has been the best ambassador for rescue by befriending every single foster we have taken in. He 'shows them the ropes' and the routines. He shares his toys, his food, and his bed—and teaches our fosters how to play again. Best of all, he shares *me*. He lets me shower the new, scared dogs with love, and he never gets jealous. Because of Will, we have been able to foster dozens of dogs who were later able to find good homes. Will is my sweetheart, and I love him."

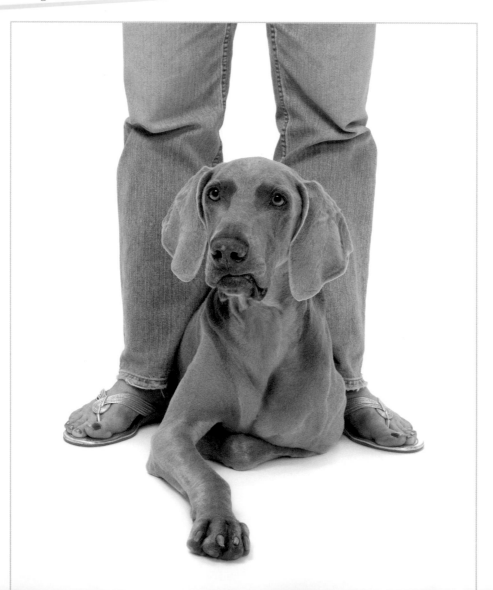

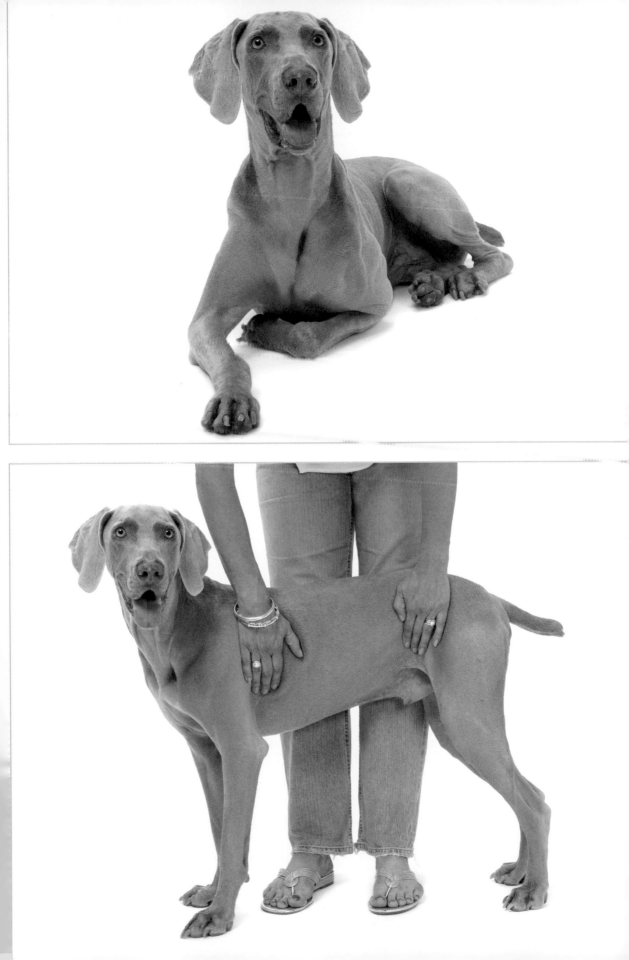

● Penny

"When an officer from the humane society saw the horrible conditions at a local kennel, along with abused and neglected dogs, he closed the place down. Among the dogs that were rescued

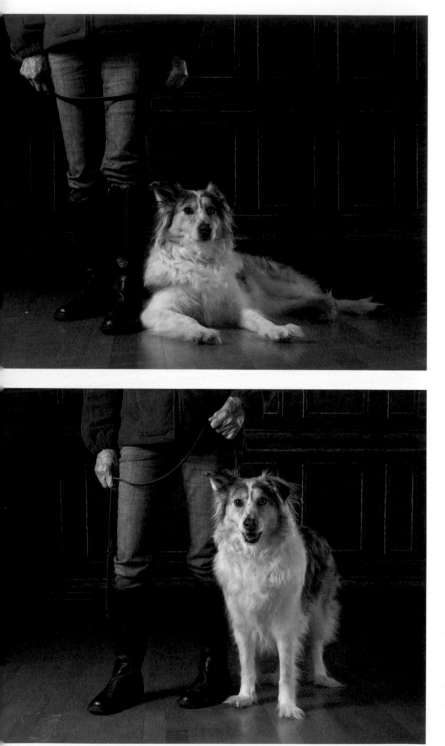

was Penny, a blue merle Australian Shepard. One eye was blue, the other brown—and both eyes were quiet and sad.

The rescue group saw her soul and potential as they set about bringing her back to health. After four weeks of medical attention, she was put up for adoption. She still needed treatment for heartworm, and her new owner would be responsible for that.

We toured the shelter facility, looking for the perfect dog for an old lady (me), and my neighbor, who came with me. We walked past the glass enclosures and finally, there was Penny. She was alone, curled up in her bed. She looked at us with eyes that said she would love us best, forever. We adopted her.

Penny has regained her health. She now knows that backyards are for chasing squirrels. Each day, we walk the neighborhood, where doorbells ringing mean loud barks, and friends mean a big welcome. Penny is a generous, gentle, and loving dog. She is happy and playful, and still loves us best and forever."

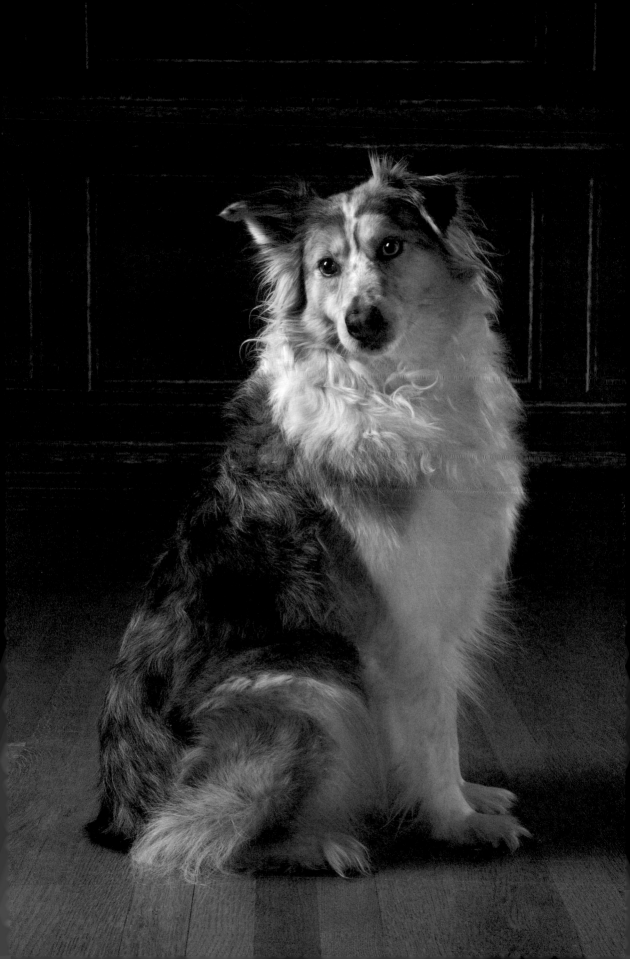

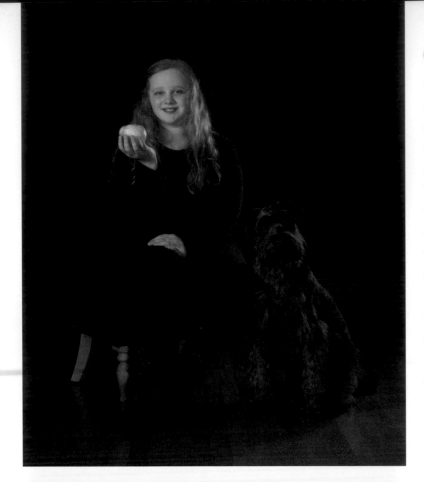

● Monty

"We spied Monty in a group of rescue dogs outside of a pet store. We were told he was found, along with another dog, on the side of the road. We weren't exactly expecting to get a dog that day, but we ended up spending two hours with Monty and decided to adopt him.

Monty is a gentle, lazy, boy who loves people. He was quick to train. He will do anything for a treat, especially apple slices!

Monty has brought us so much joy. He's always happy to see us when we come home. He jumps and wags his tail with love. He's a human shadow and follows us all around the house. We are so happy he's part of our little family."

"He's a human shadow and follows us all around the house."

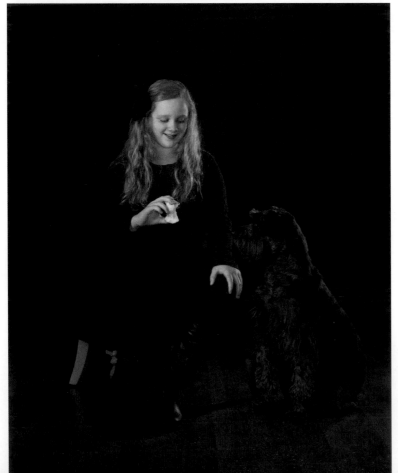

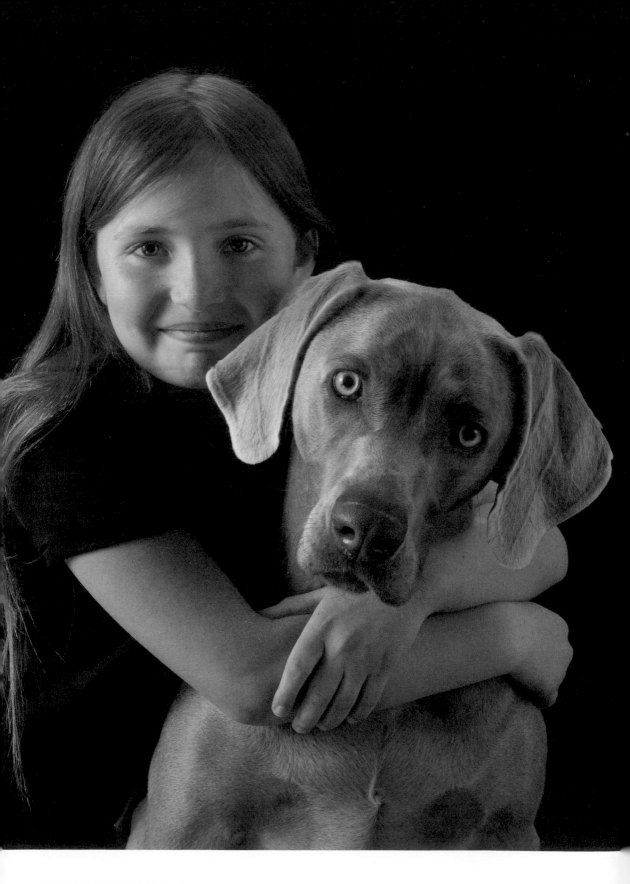

● Cadbury

"We hate to think of Cadbury wandering the city streets alone before she was picked up by animal control. Or thinking of what whoever dumped her in the streets was possibly thinking. But she made it into rescue, where we found her.

Cadbury is a lively, sweet, and exuberant addition to our family. She loves to play hide and seek with my daughter, Claire. We all love her and look forward to coming home at the end of the day to see her. She is a love, with personality plus!

Thank goodness dogs are able to forget what happened in the past and instead dwell on and enjoy the love they are now giving and receiving. We can't imagine our lives without her."

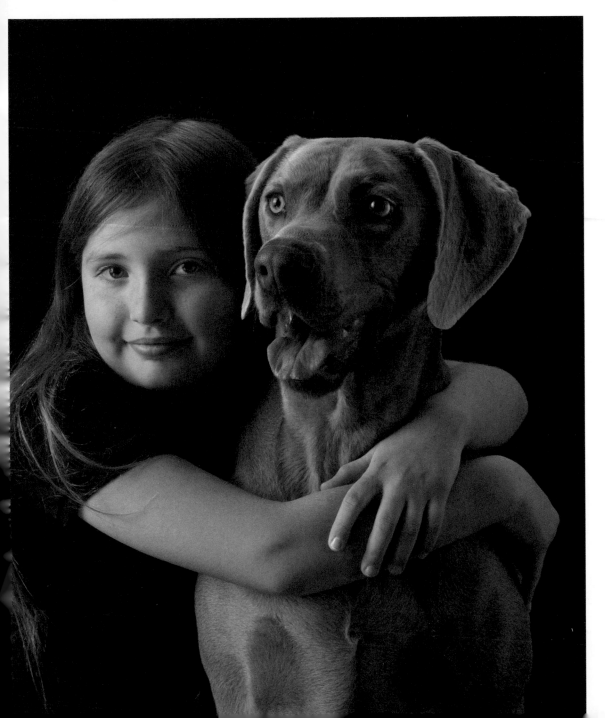

● Granger

"I know little of Granger's background. I do know that he was found abandoned, and somehow found his way into rescue. He was a big dog at 98 pounds. I decided to name him after my best friend.

Granger is gentle and sweet. The sound of the leash gets him excited. He is a wonderful companion and is always ready and waiting to go for one of those nice, long walks."

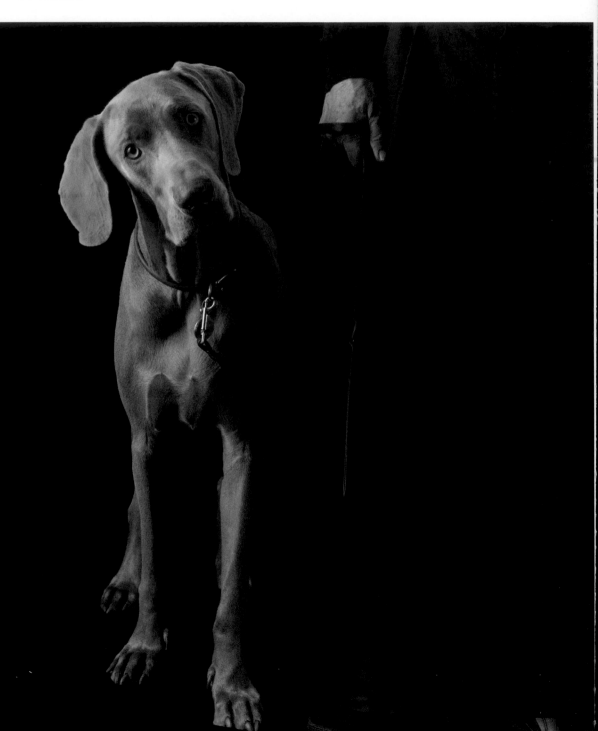

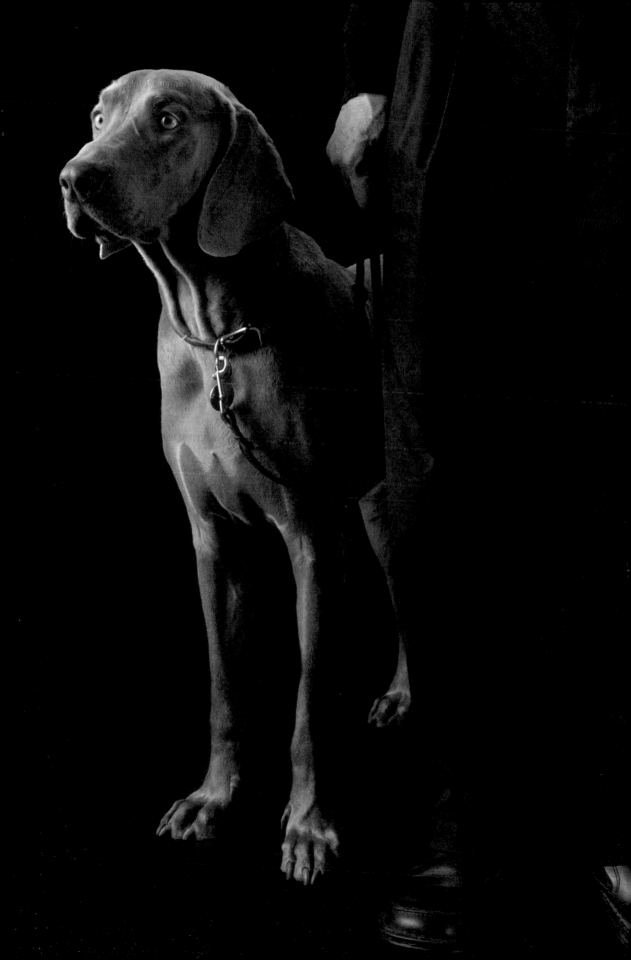

Jake

"Jake is a dapper little Affenpinscher from Affenpinscher Rescue. He was an owner surrender, and less than a year old when we adopted him.

When Jake is not sitting on his adopted dad's lap, he enjoys sitting high on the staircase, watching him practice the violin. While Jake doesn't attend the symphony, he does travel frequently. He serves as an ambassador for Affenpinschers at 'meet the breed' booths at various dog shows around the country. In addition to meeting people, he also likes doing obedience and rally.

In our home, he is a much-loved member of the family."

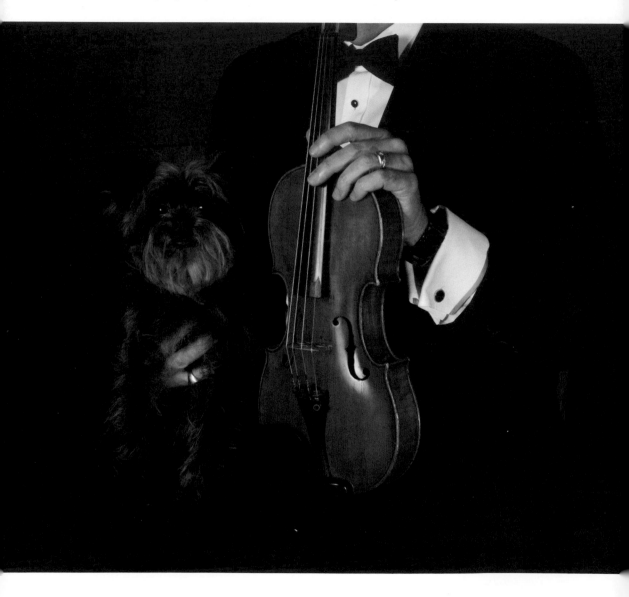

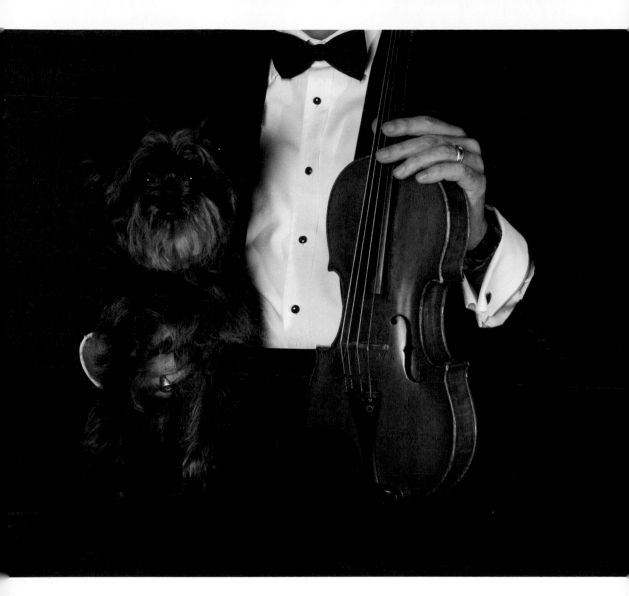

'When Jake is not sitting on his adopted dad's lap, he enjoys sitting high on the staircase, watching him practice the violin."

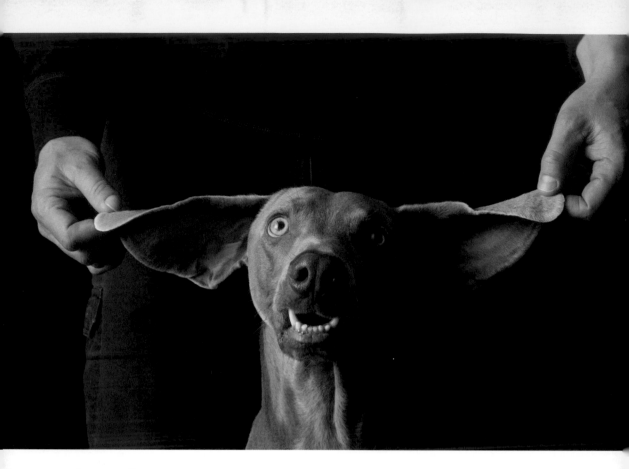

● Rowdy

"Rowdy and his brother, Poncho, were abandoned at the shelter one night by their breeder. A rescue group pulled them both from the shelter and fostered them. We decided to adopt Rowdy, and Poncho found another family.

Rowdy was very scared at first, but he could scale a fence, and chewed everything in sight. Over the next few months, Rowdy and his new family figured out how to live together. We have had other Weimaraners, so we knew about the breed.

Rowdy is very sensitive and loyal, and perfectly content to be where we are. He is still shy around other people, but no longer hides. He holds a very special place in our hearts. He is an angel without wings. Rescue is as much a blessing for humans as it is for the dogs."

"He holds a very special place in our hearts. He is an angel without wings. Rescue is as much a blessing for humans as it is for the dogs."

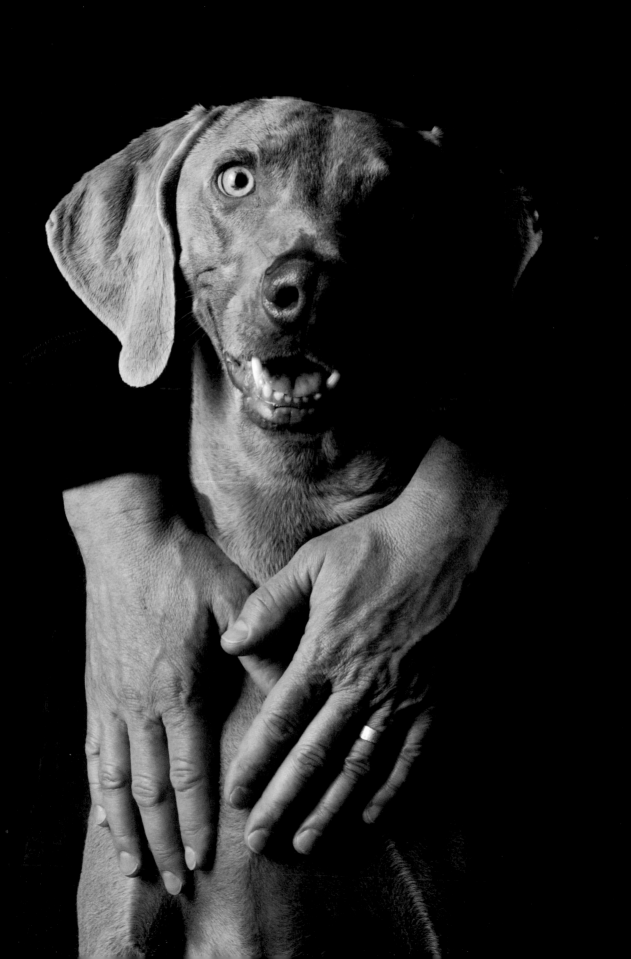

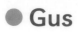

Gus

"Gus was adopted from a rescue group as a companion for one of our other dogs. He was the perfect complement for our shy, adopted Pit Bull.

The big surprise was how much he was a playmate for our young son, Zane. Zane and Gus share a love of making mischief and enjoying yummy snacks. They bring out the silliest parts of each other's personalities and will play until exhausted. Their time together is always filled with laughter. At the end of the day, both love curling up in my lap for snuggles.

Gus is smart and learns tricks quickly, but I'm not sure if we have trained him, or it's the other way around. All it takes is a look from that sweet face with the big eyes and even bigger under bite, and we are ready to give him whatever he wants!"

"Zane and Gus share a love of making mischief and enjoying yummy snacks. They bring out the silliest parts of each other's personalities . . . "

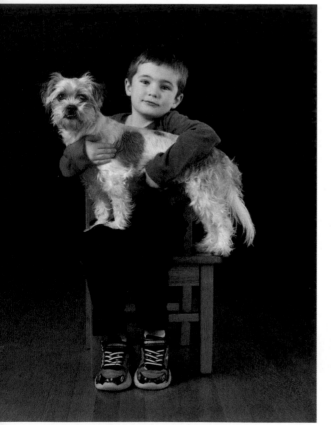

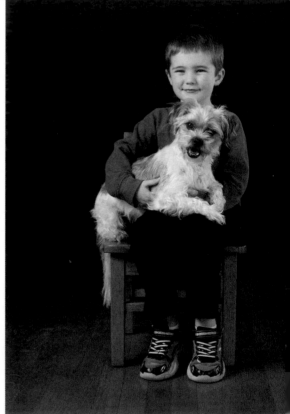

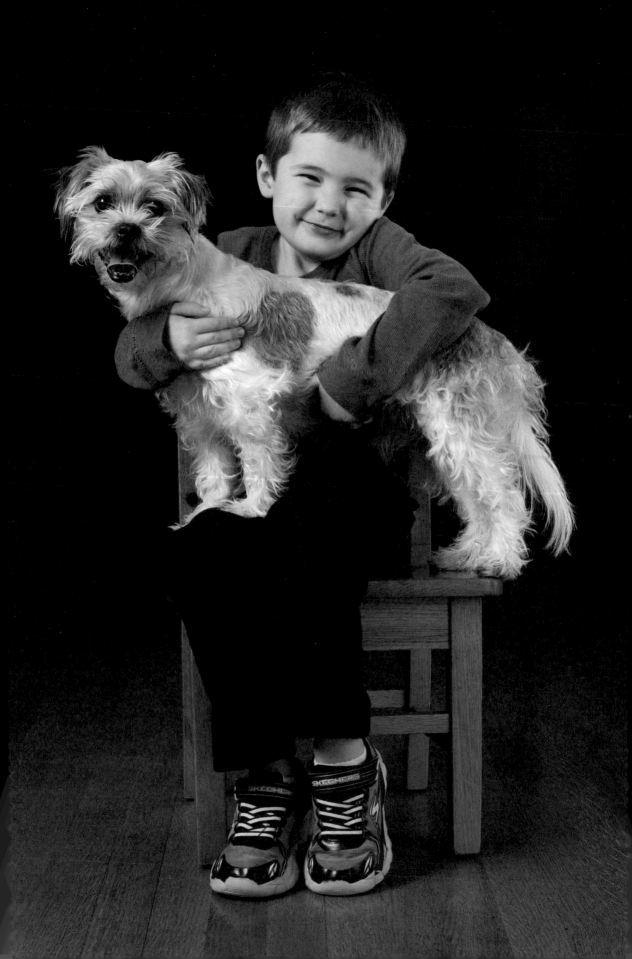

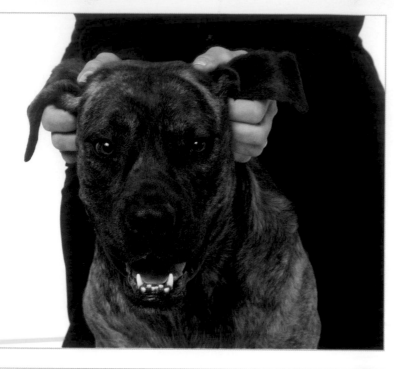

● Queen

"My name is Queen, and I am a two-year-old Bull Mastiff. When I was 10 months old in the hot Texas weather, I found myself in front of a house. A young lady came out of the house on her way to work, saw me, and came to comfort me. She made a phone call, and then put me in her backyard. I was dehydrated, skinny, and weak.

I had my picture taken, and became a social media star for the next few days. Shelters were contacted; people were looking for my owners. They never came forward, so the family that found me told me I would be staying with them.

I was excited to be with this awesome family. That is when all of the good stuff started happening. I gained back a lot of strength. I got nice and healthy.

I enjoy being loved on and having my neck and ears rubbed. I am so happy to be home!"

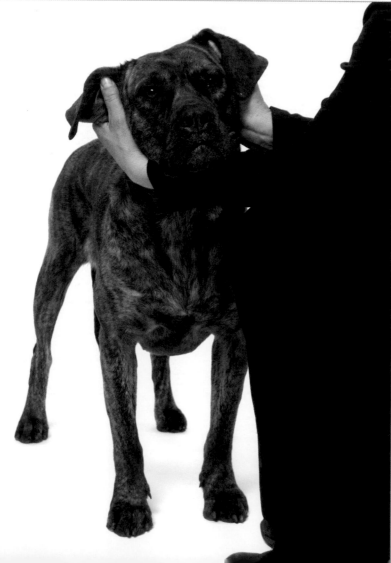

"I enjoy being loved on and having my neck and ears rubbed. I am so happy to be home!"

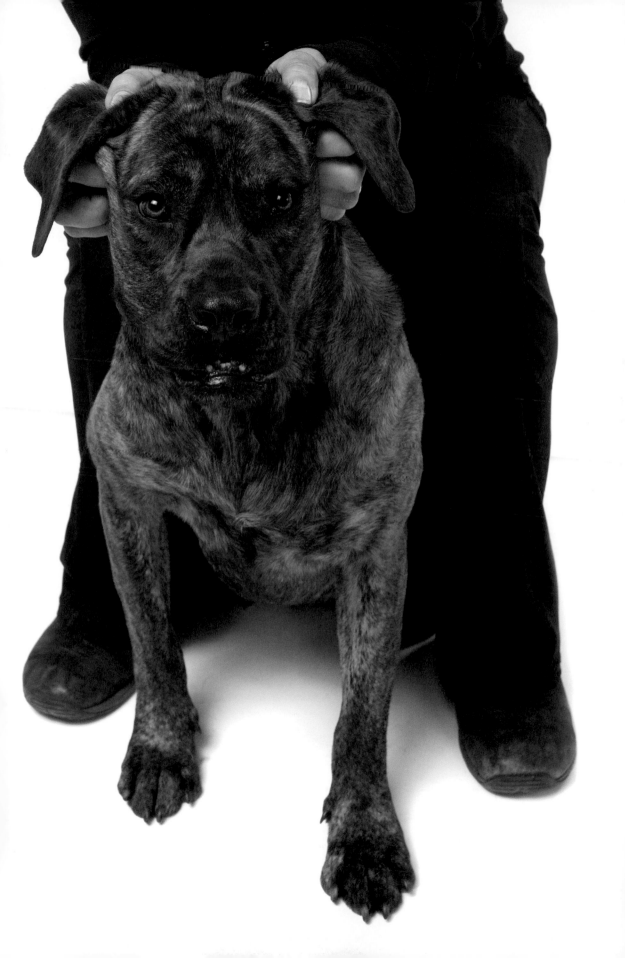

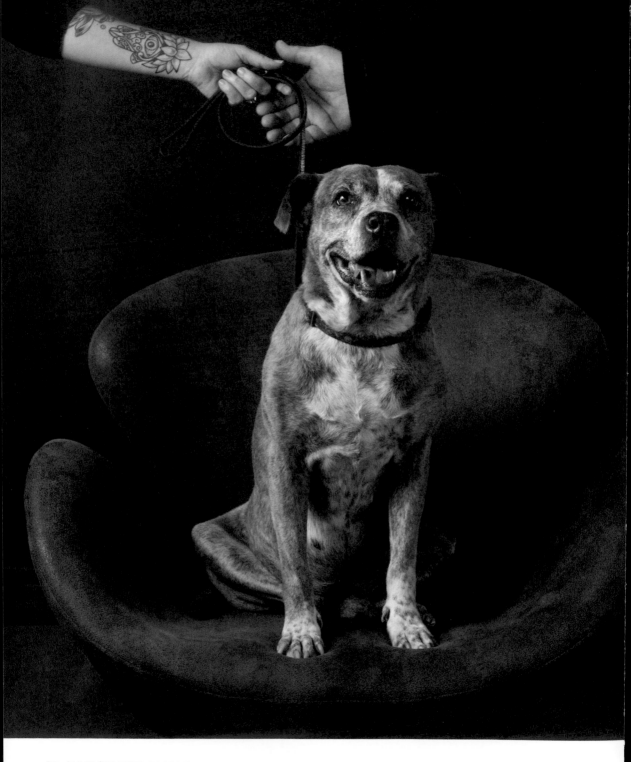

● Denim

"Denim was with her foster mom for a year and a half before her rescue group finally found a home for her. It was *my* home. I was looking for a dog to keep my male dog, RJ, company.

Denim was a good napper, loved to eat, adored belly rubs, and was incredibly protective of RJ. She wasn't much for toys or balls, but she sure was crazy about bones. Anything that resembled a bully stick or rawhide was hers—even if it wasn't here, it was only a matter of time before it was, in fact, hers.

I never really grasped how much Denim meant to me until she was diagnosed with Cushing's disease. My vet explained that the treatments and meds would be extremely pricey. I spared no expense trying to help her have a good quality of life through a very debilitating disease. After two years, her quality of life deteriorated to the point that I knew it was time to let her go. I have no regrets about the costs, only that I didn't rescue her sooner and couldn't cure her.

People often ask me why I rescue only Pit Bulls. 'They scare people,' they say. Most of the time, I smile and say nothing. If they persist, I tell them, 'Pit Bulls are not out to hurt anyone. All they want is to love you and steal your heart.'"

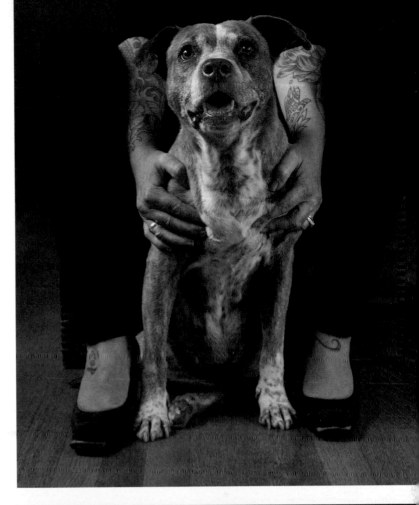

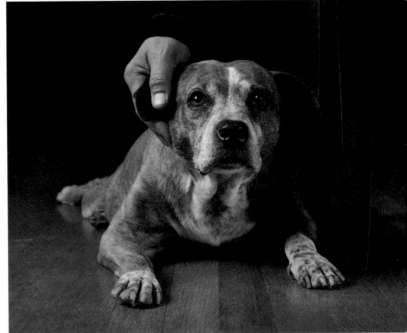

DOGS JUST WANNA HAVE FUN

● Barkley

"Barkley came from a rescue. His previous owners worked all of the time, and he spent most of his first year in a crate. As a result, he was a huge, awkward 'puppy' that had no endurance or awareness of his own body. Eventually, he ended up in rescue, just in time for when we were looking. We did not choose him, he chose us. He came to us as a foster dog and never left.

With us, Barkley learned to play (and play, and play, and play). He is equal parts companion and nuisance, huge dog and 'lap' dog, beautiful and goofy. Whether Barkley finds trouble or trouble finds Barkley, he is constantly into mischief. But as my son said, 'We can't give up on him, because someone already gave up on him once.'

We adopt our dogs forever. Lucky Barkley, and lucky us!"

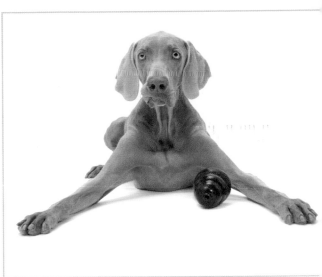

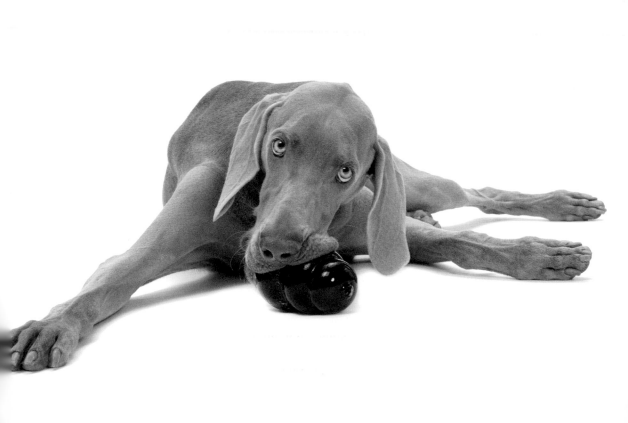

● Olive

"Olive's history is a mystery to us. She was found scrounging through trash behind a bakery. She was just a puppy, most likely five or six months old, and was very scared and skinny. Lucky for her, the bakery owner took her in and brought her to a trainer friend of mine. The trainer couldn't foster her, so I agreed to take her as a foster. The plan was to socialize her, teach her some manners, and then re-home her.

Olive picked up on obedience training quickly, but she was afraid of everything! It took weeks to get her comfortable in our home. After a while, it became clear that we were too attached to this adorable, quirky dog to let her go. She became a part of the family.

Olive still has significant issues with fear and aggression. We work every day on her issues.

Her mental and physical health depends on lots of exercise. We play games and do agility, but one of her favorite things to do is to go biking. We hook her up and she runs next to the bike for one or two miles at a time. I think it has done wonders for her confidence, and she definitely enjoys it.

People say Olive is lucky that she found us, but we feel like the lucky ones. We get to share our home and our lives with this wonderfully sweet dog who loves us unconditionally.

Dogs with Olive's issues often end up being euthanized or being re-homed multiple times. I feel very blessed that we are able to give her what she needs. We were brought together for a reason, and we fully intend to keep her happy and safe for the rest of her life."

"After a while, it became clear that we were too attached to this adorable, quirky dog to let her go. She became a part of the family."

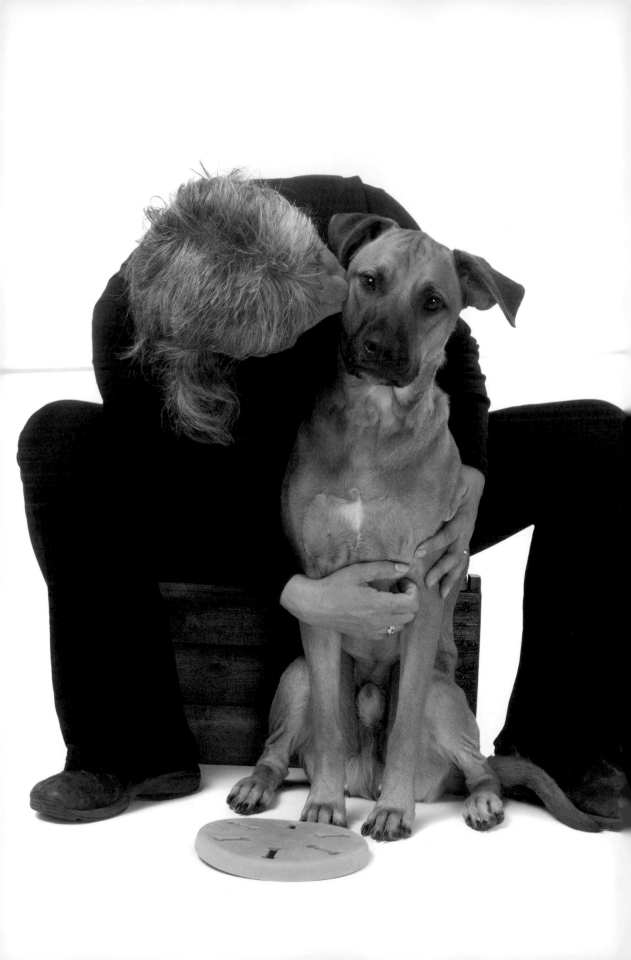

● Bobby

"My name is Bobby. When I was six months old, I was roaming the streets with other dogs. A young lady came out to try to feed me and catch me. I was skittish. Then an older lady joined in. After 45 minutes, they cornered me. The next thing I remember is being in a rescue kennel, getting a bath.

A month later, a volunteer took me home. I was scared, but everyone seemed to accept me. I got comfortable quickly. I learned to really like walks. I like to play chase, but I especially love playing Frisbee with my mom. It's the 'best-est' thing to do! I am a good dog and love pleasing my parents."

"I especially love playing Frisbee with my mom. It's the 'best-est' thing to do!"

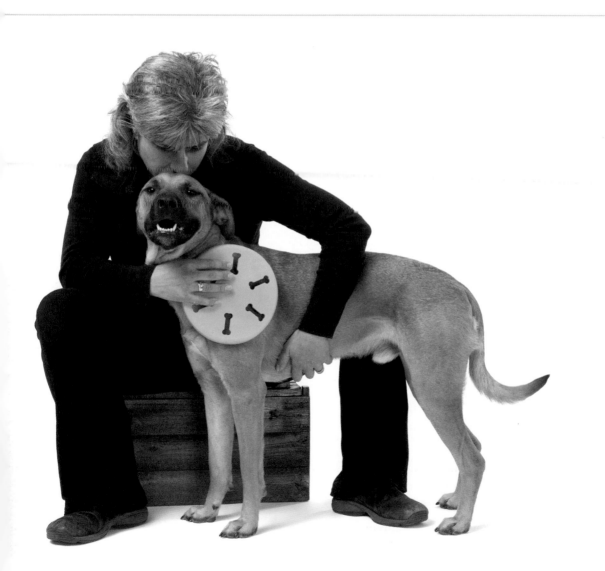

● Henry

"My name is Henry, and I am an older dog. At this moment, I am probably lying in a spot of sun or on the couch.

Ten years ago, I adopted my family. I was too young to remember the time before I met them. All I can say is that a rescue group took me in, fixed my health issues, and got me on my feet.

When I was adopted, the real work began. I had to teach my new family how to handle certain situations, and I had to test the boundaries

"At this moment, I am probably lying in a spot of sun or on the couch."

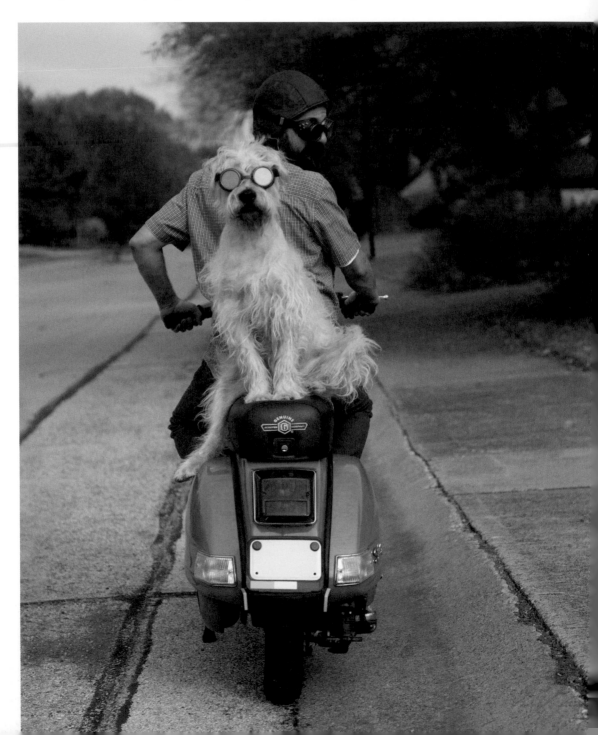

to see how resilient they were to stress. I enjoyed chewing doorjambs and letting myself out of locked doors to roam the city.

I decided to get professional help and joined a training club. It helped me tremendously to teach my people how to communicate with me. Looking back, I must say they did okay.

I love the water—the ocean, the lake—anything wet and dirty. Whenever I have a chance to get my skin wet, I will take my chance. But please don't get me wrong, I do not like to get a bath. That is a big *no*!

I also love riding in the car with my family. That is the second best thing in the world! I wish my Papa would take me for rides on his scooter, but he says I am not old enough!"

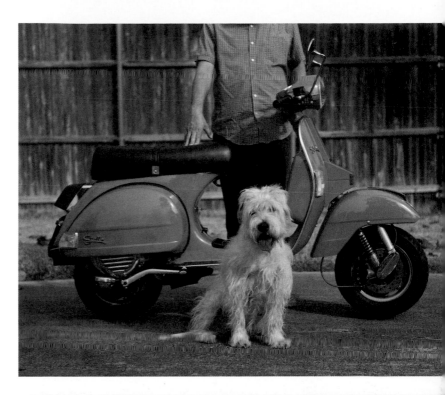

"I wish my Papa would take me for rides on his scooter, but he says I am not old enough!"

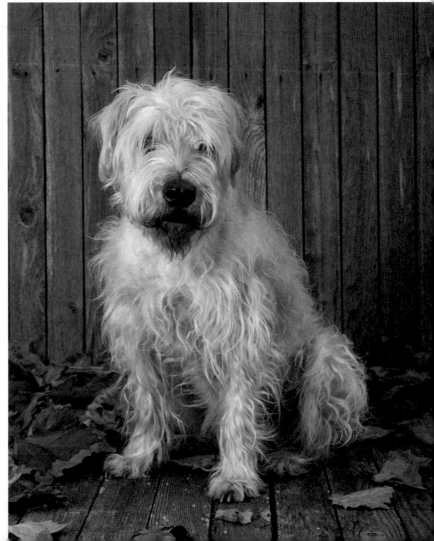

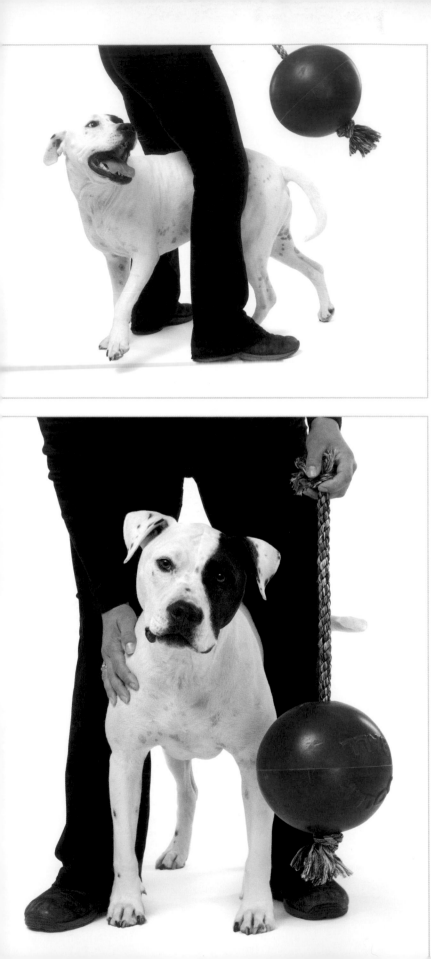

● Jack

"Captain Jack is my name, and I am a Staffordshire Terrier. I have black spots, with a big black spot over my left eye. That's why I am called Captain Jack.

When I was about a year old, my owners moved. They left me in the house with no food or water. Luckily, a person found me and turned me over to a shelter. A rescue group pulled me from the shelter and placed me with a volunteer for one night until they found a place for me to stay. I must have made an impression, because that volunteer said she would keep me for a few more days. By the end of the week, that was my forever home.

I am a high-energy dog. All I want to do is play, go for walks or runs, and chew toys. I always try to find someone to play with. I start with my humans to see if they will play fetch. If that does not work, I will shove a toy in any dog's face until someone will play with me. I am so persistent that someone gives in eventually. My advice to you would be to never stop playing!"

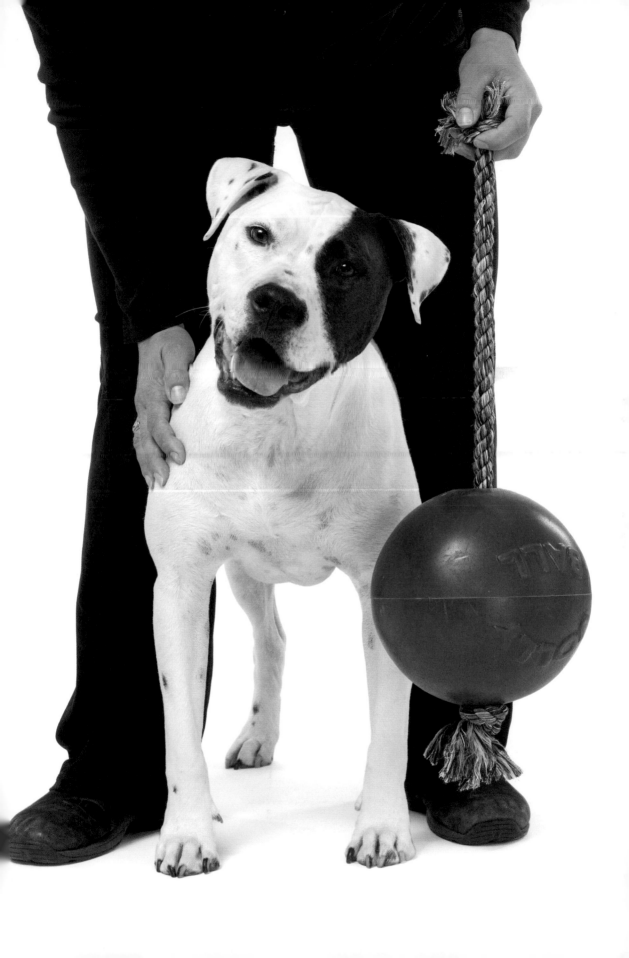

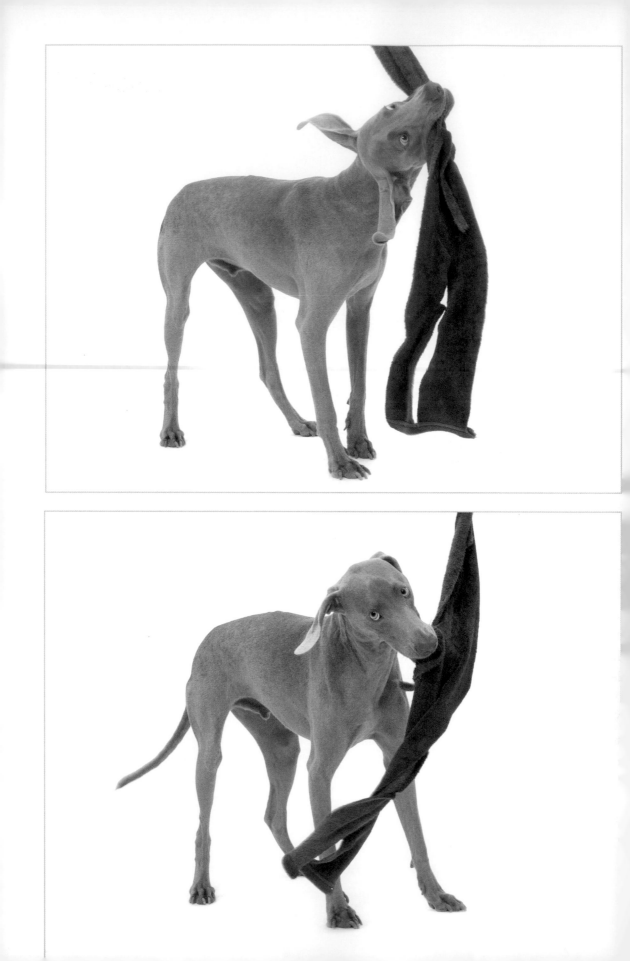

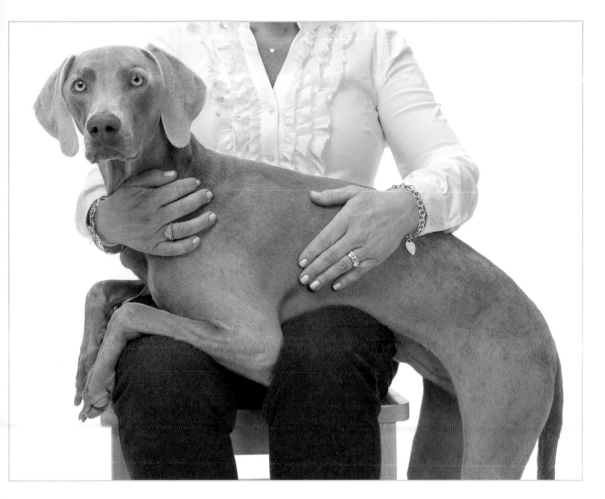

● Miles

"Miles was possibly abandoned shortly after birth. He was turned over to a vet at four months, and then sent to rescue, where he was fostered until he found his forever home. He had many medical issues and a very high energy level.

We were looking for a companion for our Weimaraner, and went to Weimaraner Rescue to find the right match. Rescue was not recommending Miles to us because of his high energy level, but we still wanted to meet him.

He was so much more than we were looking for, youthful exuberance and all. We kept him for an overnight visit. We called the next day to extend his stay. The next day, we called again—and the day after, and the day after that. Miles never went back to his foster home. We adopted him.

Miles will eat anything! He has his fun chewing on everything. He still has a little strip of the blanket he came to us with. He is just sweet enough that we don't get to angry over his destruction of things.

When he is not chewing things up, Miles will come and place the front of his body across me while I am working at my desk.

We are thankful to have this wonderful guy in our lives."

King

"My name is King. When I was two years old, my owner, who was a drug dealer, died of a drug overdose.

My sister and I quickly found ourselves at the shelter on the euthanize list. Rescue saved us from that dreadful fate. My sister got adopted quickly, while I stayed behind. I got depressed, stopped eating, and lost a lot of weight.

One of the volunteers saw me and called her husband. The next thing I knew, a man pulled me out of the crate and took me for a walk. The following day, I got to the volunteer's home and knew I'd end up spending the rest of my life there.

Within a few months, I got to a healthy weight. I enjoy the walks we go on. Treats are awesome. I also have two ropes that hang from a tree. I jump up to grab them and swing, tug, and pull. Once I shred the ropes to pieces, I get new ones, and I go at it again. I am so glad I was rescued. I am having so much fun!"

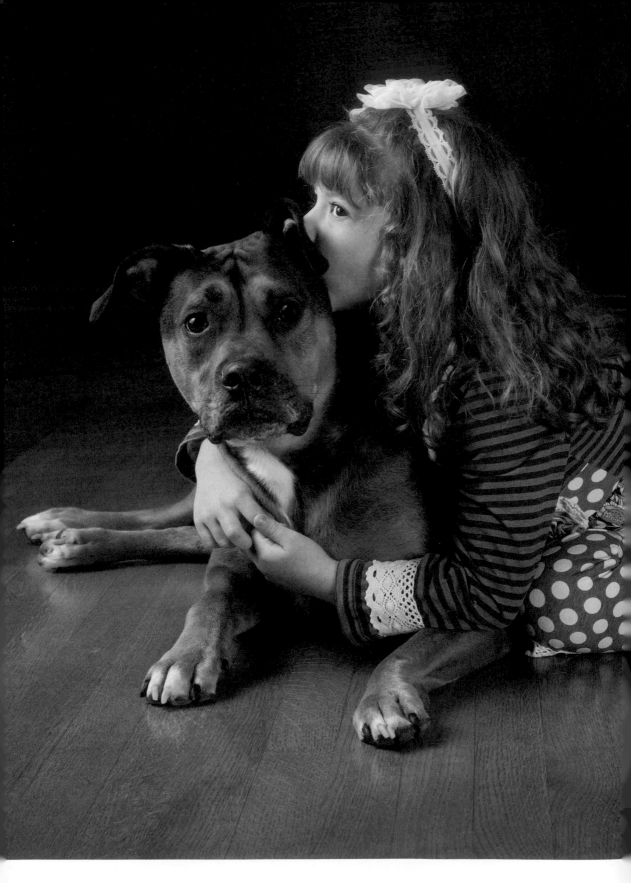

Miley

"Miley was pulled from the city animal shelter by a rescue group when she was about three months old. She had been found injured on a city street. After the rescue group took her in, they healed her wounds. She was then adopted by a single lady. The woman worked long hours, and Miley was crated all day. Ultimately, the adopter returned her to the rescue group.

I met Miley when the rescue group held an adoption event at a local pet store. I fell in love with this great big, 50-pound, lovable puppy.

We introduced Miley to my very young daughter, Kaitlyn. We were unsure how Miley would do with her, because of her size. To our astonishment, Miley lay down on the ground and gently kissed Kaitlyn. When the pair played with a soccer ball, Miley taught herself to slow down and be gentle with Kaitlyn.

During one of these play dates, Miley discovered that one of Kaitlyn's favorite things to do was blow bubbles. When Kaitlyn blows bubbles, Miley chases them; she even leaps up

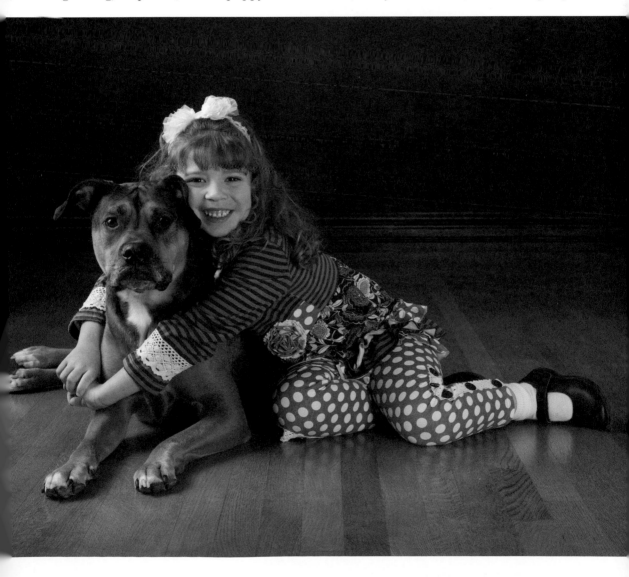

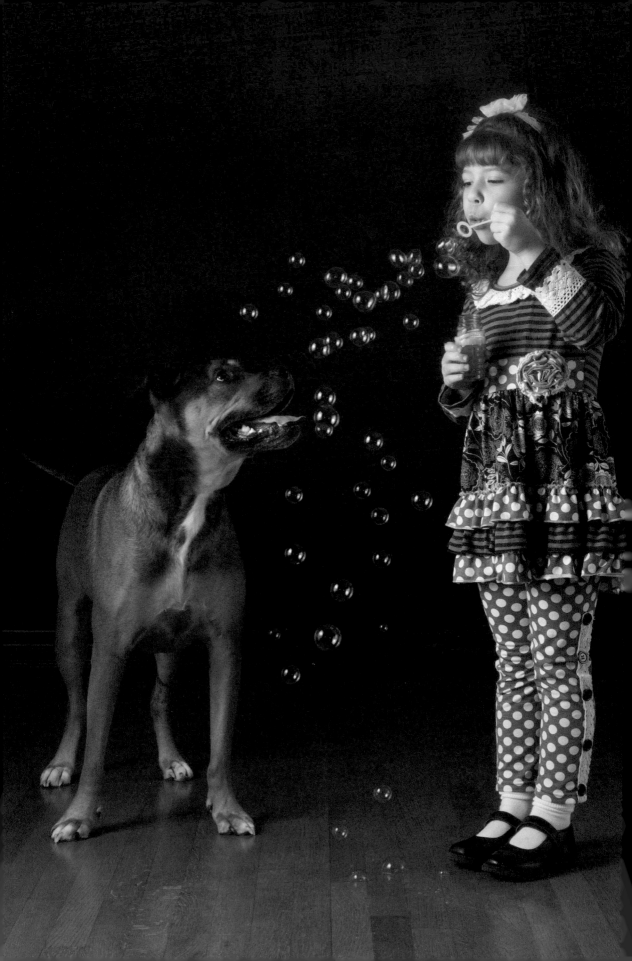

to catch them. This is their favorite game to play together.

Miley's patience and love for Kaitlyn is like nothing I've ever seen before in a dog. The bond between them is beautiful. They truly are best friends. Now that we have Miley, we cannot imagine life without her, She brings so much joy and laughter into our home."

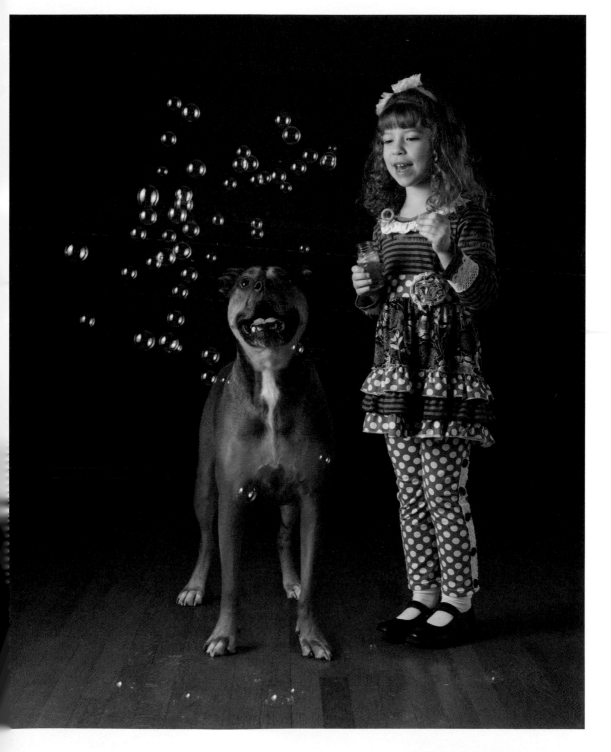

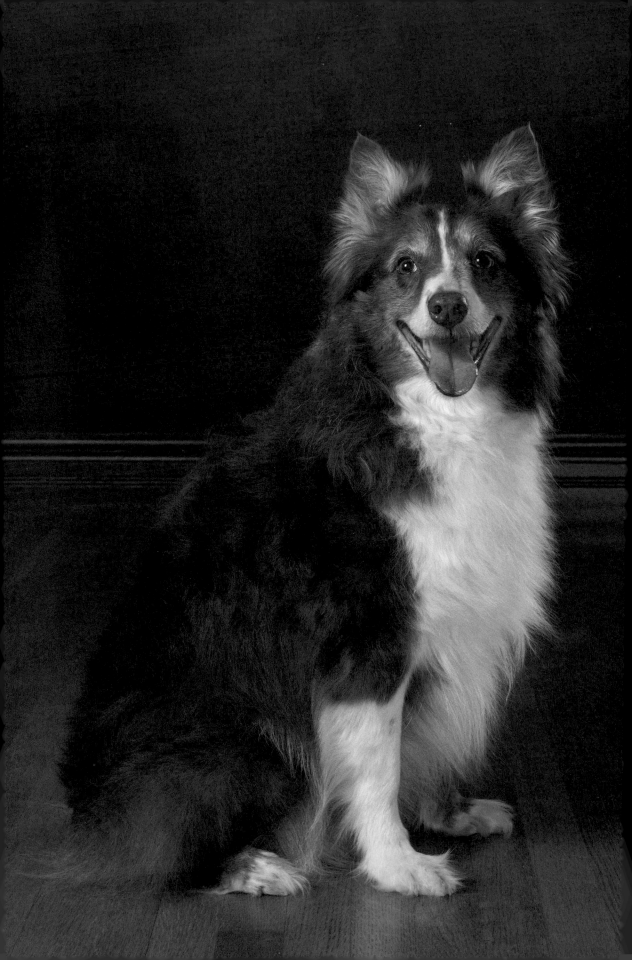

MAKING A DIFFERENCE

● Shaylee

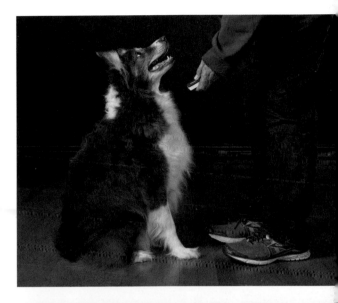

"Shaylee was a 'free dog' advertised on a scrap of paper pinned to a bulletin board in a rural feed store. A smart, energetic pup, she had been kept outside on a chain. Initially, she was taken into my home as a foster dog and was placed up for adoption. She quickly charmed her way into my heart and became a member of my family.

Shaylee tried to explore everything she could. To help focus her energy, I started training her. I was amazed by how quickly she learned things. She would master a new behavior after about three repetitions. She would spontaneously chain together those behaviors to create unique new sequences. This talent and drive to learn, and her natural enthusiasm for fun, made her an ideal dog to use with troubled, sick, and challenged children and teens. As a therapy dog, she worked with them, always bringing laughter and joy.

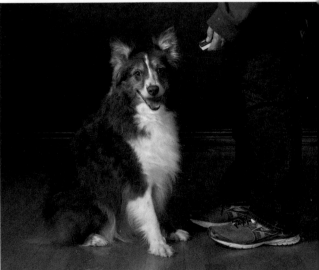

As she matured, Shaylee added visiting and entertaining the elderly to her busy schedule. She was as at home performing tricks as she was cuddling up for some hugs and kisses.

Shaylee has brought much love and joy to my home, and she has spread it all around to those who want to receive."

● Gump

"Gump was born at our home. His mother was our foster dog. We did not know she was pregnant until two weeks before her twelve puppies were born.

Gump is a survivor, having made it through all of his early hardships, but he is also our baby. He is funny, curious, friendly, and loving. He sits on the stairs that face our front door and looks out the window, observing the happenings in the neighborhood. He is our cuddle bug; he is always eager to sit on us or lie down next to us.

Gump also helps us with our foster dogs. He changes his personality to best fit his foster sibling's needs. When alpha dogs are with us, he is submissive. When leadership is needed, he is ready to teach. When a dog is sick or shy, he offers comfort. Gump has never known cold, hunger, or loneliness, but he is able to help all the foster dogs that we bring into our home.

We can't imagine being without Gump, our baby boy, and can't believe all the joy he has brought to our family."

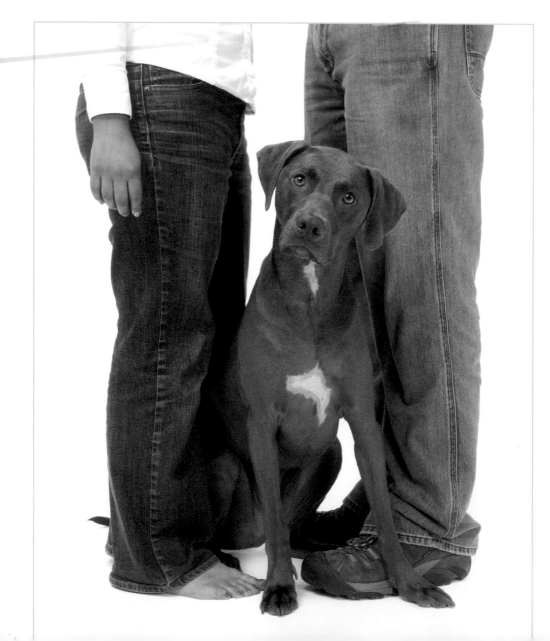

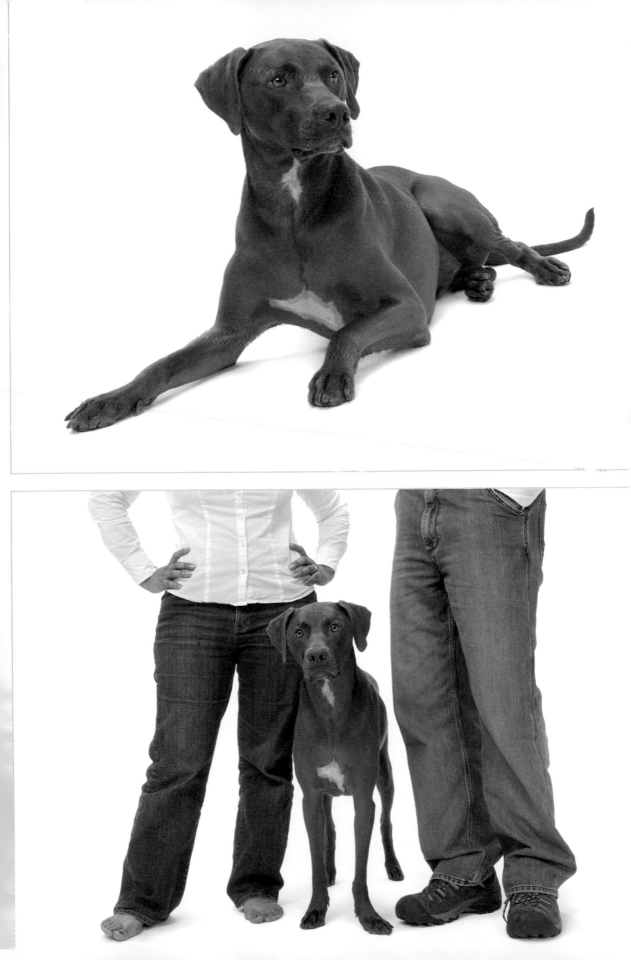

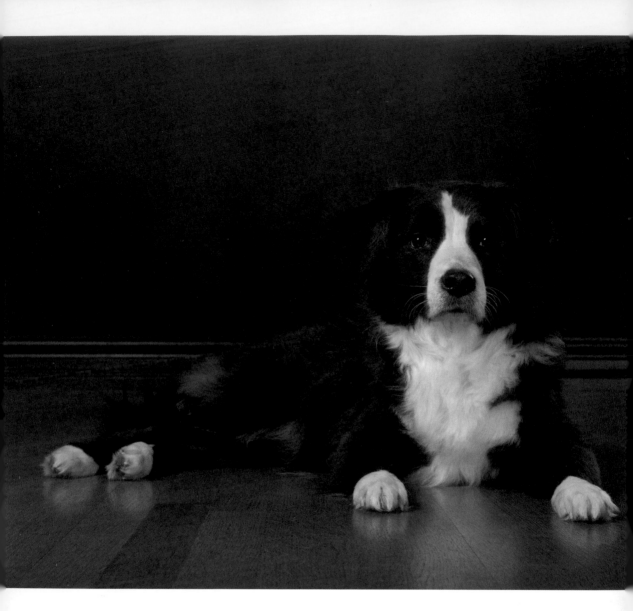

● Tzarina (Magic)

"Tzarina was found as an eight-week-old puppy, wandering near a street. She was picked up by animal control and taken to a newly opened shelter. A few days later, the staff contacted me and asked if our rescue could take her. They said everyone there called her 'Magic Puppy,' because whenever anyone picked her up, tears would start flowing.

I skeptically arrived to retrieve the puppy, joking with the shelter workers that they were 'softies.' That was until I picked her up and I started to cry. She had huge puppy eyes and such a sweet, heartbreaking expression. After admitting that the shelter workers were right, she was a Magic Puppy, I took that sweet little thing to her new home—*mine!*

She has always been sweet-natured. For years, she gently taught quite a few frightened rescue puppies how to play. She patiently worked with reactive dogs so they could learn to trust new

dogs. She also became a regular at the local Alzheimer's facility, where she enjoyed playing 'tea party' with the ladies and flirting with the gentlemen. She prefers low-key visits, as she can sit and socialize quietly, but she is silly and playful at home. She truly is a Magic Puppy, and she has stolen my heart."

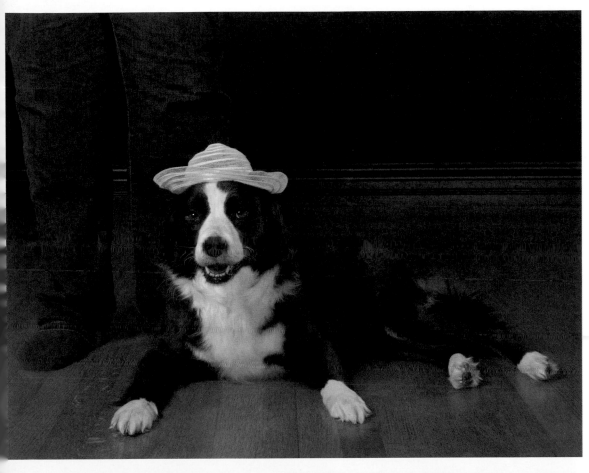

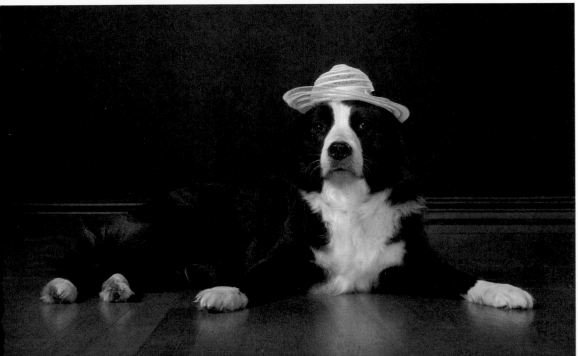

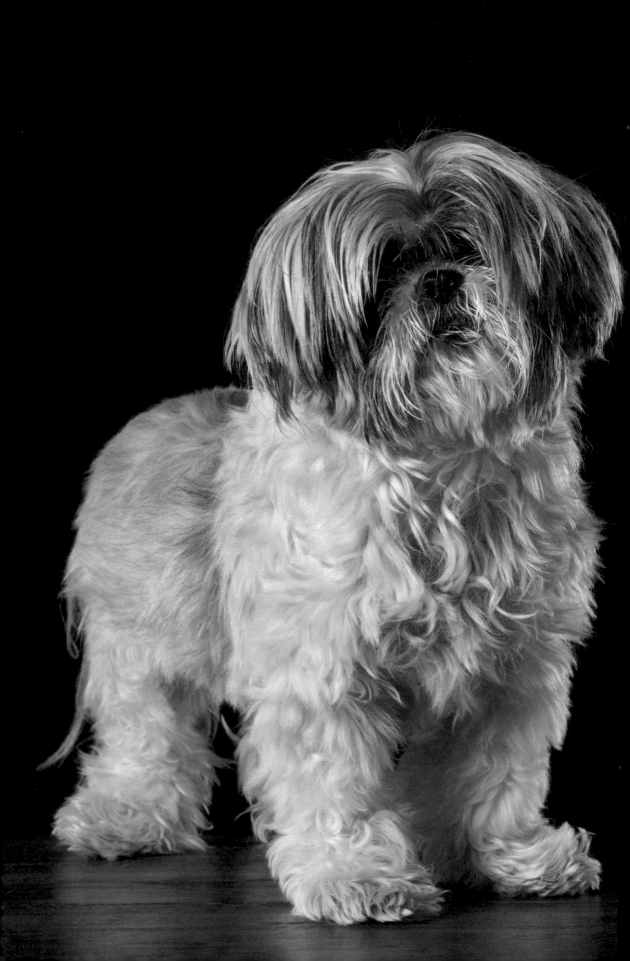

● Orli

"Orli is a Katrina dog. I had seen her in a photograph that accompanied a newspaper article about an oil-spill cleanup after Hurricane Katrina. She was a little dog all covered in oil. The newspaper gave her the name 'Oily Dog,'

The photograph of the little, oil-soaked dog and the story made such an impression on me that I read and re-read the article, and something in my mind said I needed to do everything I could to help the little dog.

I contacted hundreds of people and even sent 100 large plastic posters to the area where the little dog had been photographed. I offered a $1,500 reward. Over the two-and-a-half months or so I searched for the little dog, I received close

"The photograph of the little, oil-soaked dog and the story made such an impression on me . . . "

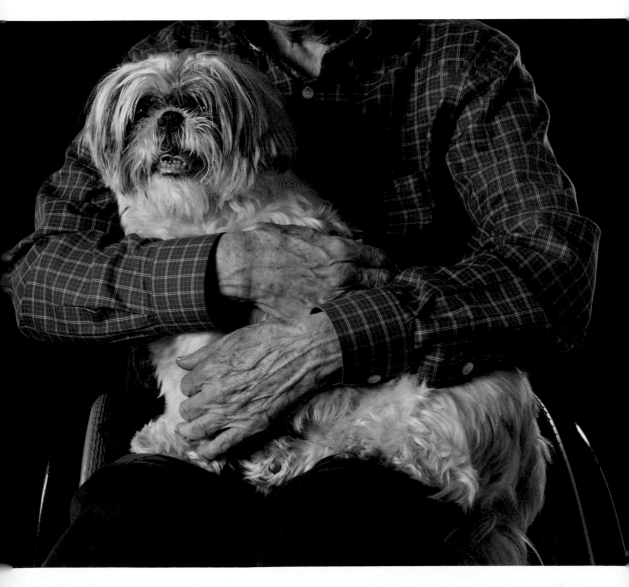

to 6,000 emails from people wishing to help, or giving suggestions about how to search for the dog.

I was about to give up when the phone rang, and a lady who was with the St. Charles Parish Animal Control told me she lived near the area where the dog had been photographed. Through a roundabout series of events, she now had the dog. She went on to tell me that I could not have the dog because she did not know me or know what I might do with the little dog. Add to that the fact that I lived 550 miles away.

We talked for a few minutes, and I asked if I might have someone from a local animal rescue check me out, and she could call my veterinarian to show that I take care of my current dogs. She said she would consider that if she still had the little dog when the report arrived.

I found the local Shih-Tzu rescue and told them my story. A couple of days later, they visited my home, and everything checked out. I had my report for the St. Charles Parish Shelter, and they agreed to let me have the dog. I needed to come get the dog as soon as possible.

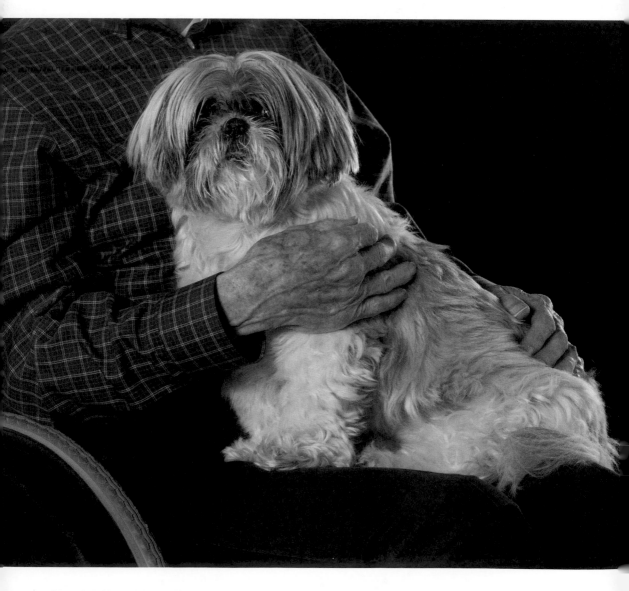

With four new tires on the van, off we drove to New Orleans. I went to the agreed-upon location, and they handed me the little dog I had searched so many months to find. She was a really beautiful little Shih-Tzu, and we could see that she had been bathed many times and groomed. I believe we all had tears in our eyes.

They refused the reward money, but I got them to give it to the No Kill Animal Shelter Construction Fund, so it would go to a good place. We drove home. The little dog curled up and snoozed through the night.

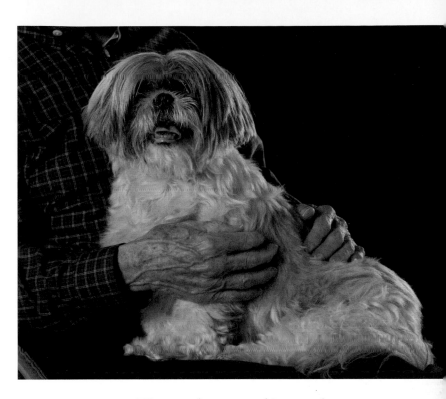

I went to the agreed-upon location, and they handed me the little dog I had searched so many months to find.

We knew we needed to find a new name for the dog. Somehow, 'Oily Dog' or 'Slick' were not appropriate names for the beautiful little girl. My wife found a list of baby names on the Internet, and 'Orli' seemed to fit perfectly. So Orli, it was!

At home, our two dogs made Orli feel welcome and showed her around the house and yard. We were a family.

I have had dogs since I was two years old, but have never had such a wonderful dog as Orli! I believe she was specially made to be with humans. I am in a wheelchair, and she sits on my lap all the time at home.

When we drive around I set up the passenger seat in my van to accommodate her safely. She travels with me everywhere.

I had never known any Shih-Tzus before Orli. When I was asked to be a part of a local Shih-Tzu rescue group, I jumped at the chance. We have rescued more than 1,000 Shih-Tzus and adopted these special little dogs out to families who have been very carefully vetted.

I had never been involved with rescue before Orli. What started as a quest for one little dog has turned into a project to save more than 1,000 homeless dogs. My prayer is that I will live long enough to be holding Orli in my arms when she takes her last breath and passes on to heaven!"

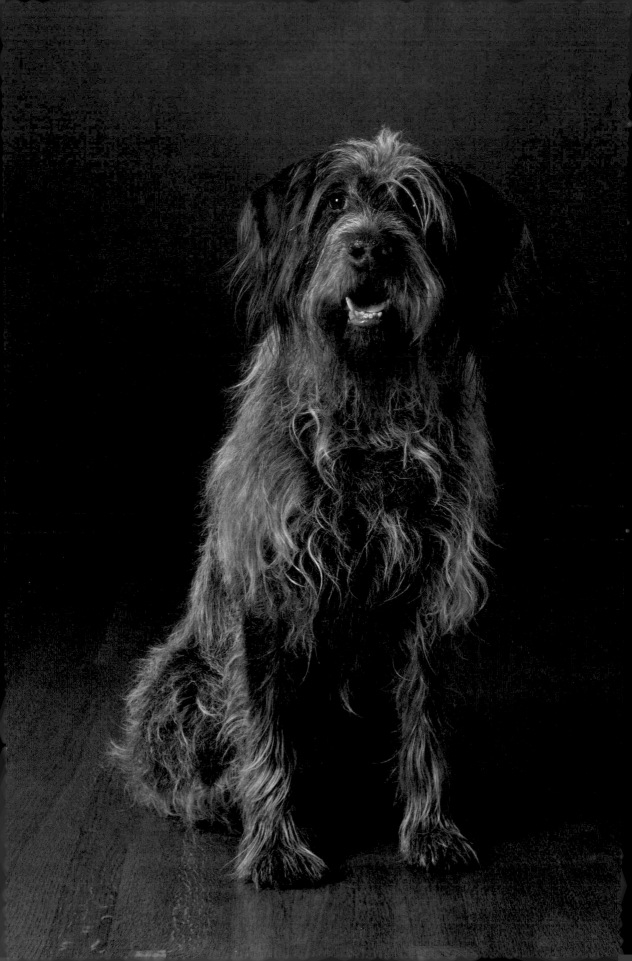

FINDING THE RIGHT DOG FOR YOU

Municipal shelters, by law, usually have to take in every animal that is surrendered to them. There is never enough room to house all of the animals that are surrendered or found on the streets, and many are euthanized. No-kill shelters have space constraints, too. They are unable to take in every animal surrendered to them, and ultimately, must turn some animals away.

Rescue groups play a vital role in saving animals. By working with the shelters, both municipal and no-kill, they serve as a safety net. They take in pets with medical or behavioral challenges, and volunteers open their doors when there is no room left at the inn. Some rescue groups are breed-specific and pull dogs of a specific breed from shelters. Other rescue groups take any dog, regardless of its breed.

Rescue groups also take on the challenge and expense of correcting any medical or behavioral problems and readying the dogs in their care for adoption. Many of the dogs they take in have been abused or neglected, and significant financial resources are needed to make them healthy again, or to provide them with the training or behavioral support to become good companion animals.

Anyone who thinks they can't find a pure-bred dog anywhere other than a breeder, hasn't looked at a shelter or a breed-specific rescue group. There are rescue groups for almost every

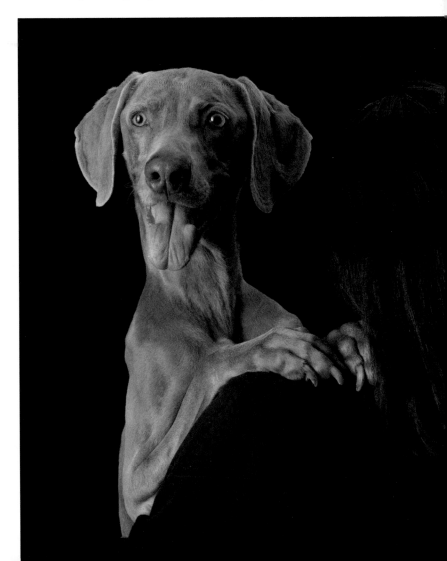

INDEX

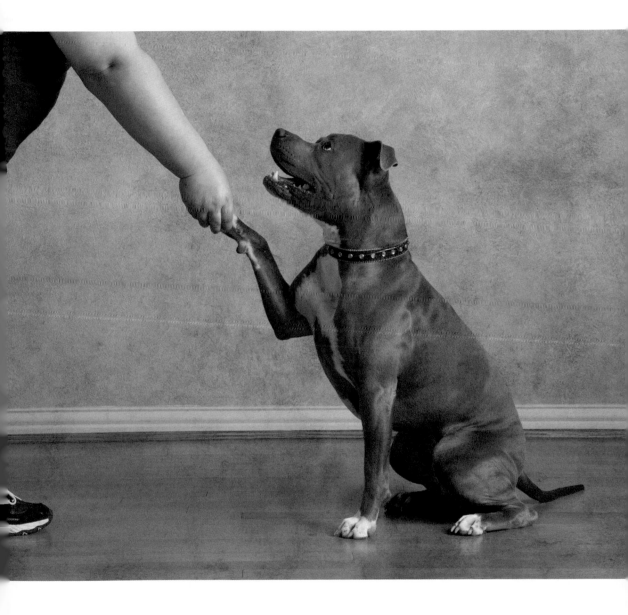

AmherstMedia.com

Dog Photography

Margaret Bryant's sweet and whimsical images capture the love we have for our dogs. In this book, she reveals the secrets to creating these wonderful images. *$29.95 list, 7x10, 128p, 180 color images, index, order no. 2125.*

The Frog Whisperer
PORTRAITS AND STORIES

Tom and Lisa Cuchara's book features fun and captivating frog portraits that will delight amphibian lovers. *$24.95 list, 7x10, 128p, 350 color images, index, order no. 2185.*

Fancy Rats
PORTRAITS & STORIES

Diane Özdamar shows you the sweet and snuggly side of rats—and stories that reveal their funny personalities. *$24.95 list, 7x10, 128p, 200 color images, index, order no. 2186.*

Burrowing Owls
A VISUAL ESSAY

Rob Palmer takes you inside the lives and antics of one of the most endearing owl species. *$24.95 list, 7x10, 128p, 160 color images, index, order no. 2208.*

Wild Animal Portraits

Acclaimed wildlife photographer Thorsten Milse takes you on a world tour, sharing his favorite shots and the stories behind them. *$24.95 list, 7x10, 128p, 200 color images, index, order no. 2190.*

Penguins in the Wild
A VISUAL ESSAY

Joe McDonald's incredible images and stories take you inside the lives of those beloved animals. *$24.95 list, 7x10, 128p, 200 color images, index, order no. 2195.*

Rescue Rabbits PORTRAITS &
STORIES OF BUNNIES FINDING HAPPY HOMES

Susan Maynard shares adorable images and heartwarming stories of sweet bunnies finding their forever homes. *$21.95 list, 7x10, 128p, 200 color images, index, order no. 2196.*

Cats 500 PURR-FECT PORTRAITS
TO BRIGHTEN YOUR DAY

Lighten your mood and boost your optimism with these sweet and fiesty images of beautiful cats and adorable kittens. *$24.95 list, 7x10, 128p, 200 color images, index, order no. 2197.*

Raptors in the Wild

Rob Palmer shares his breathtaking images of hawks, eagles, falcons, and more—along with information on species and behaviors. *$24.95 list, 7x10, 128p, 200 color images, index, order no. 2191.*

Show Cats
PORTRAITS OF FINE FELINES

Larry Johnson shares photos and stories of incredible cats and how he coaxes them into amazing images. *$19.95 list, 7x10, 128p, 180 color images, index, order no. 2166.*